T0285954

WREXHHM AT WORK

PEOPLE AND INDUSTRIES THROUGH THE YEARS

STEWART SHUTTLEWORTH

AMBERLEY

First published 2023

Amberley Publishing
The Hill, Stroud
Gloucestershire, GL5 4EP

www.amberley-books.com

Copyright © Stewart Shuttleworth, 2023

The right of Stewart Shuttleworth to be identified as the
Author of this work has been asserted in accordance
with the Copyrights, Designs and Patents Act 1988.

ISBN 978 1 3981 0285 9 (print)
ISBN 978 1 3981 0286 6 (ebook)

British Library Cataloguing in Publication Data.
A catalogue record for this book is available
from the British Library.

Origination by Amberley Publishing.
Printed in the UK.

CONTENTS

INTRODUCTION

W rexham originally developed as an agricultural centre, ideally placed on a crossover of trading routes. It is a border town, well located for markets in England. Early industry flourished in Wrexham. The county borough has a natural wealth in terms of minerals, fertile land and a network of small rivers. The close proximity of these resources to each other created the perfect environment for the entrepreneurs of the industrial age. Before the de-industrialisation of the UK, extractive and manufacturing industries were important in the area, as were brewing and leather-making in the town. A second reinvention took place after the demise of traditional industry in the twentieth century. Portsmouth University's 'Vision of Britain' study found that 'bio-technical and electronic manufacturing; human health and social work activities; wholesale and retail trade' are now key sources of work in the county borough. Wikipedia adds administration and education to that list.

The county borough council's annual performance report for 2019–20 tells us that at the end of March 2020, the employment rate for people aged sixteen to sixty-four in Wrexham was 75.5 per cent, compared to the national Welsh average of 73.7 per cent. Given a total population for the borough of 135,000, that means nearly 99,000 people are working. What do they do? What is the impact of all this purposeful activity on the culture and identity of the county borough of Wrexham and the mindset of its people? Driving down the A483, the 1980s dual carriageway that bifurcates the borough, the indicators of modern Wrexham are visible: the high rise of Glyndwr University, the Maelor Hospital, as well as the neon signs of modern multinationals. Near Bersham, a spoil heap gives away an industrial past. Digging deeper, your trip may take you to one of the largest industrial estates in Europe, 2 miles to the east. An eye-watering range of companies there coyly pursue their highly skilled work.

Today's workplaces are less visible than the town centre ones of yesteryear. Leatherworks and breweries predominated, but at an early stage Wrexham established traditions in blacksmithing, lead smelting, and woollen goods manufacture. Hidden behind the spoil heap is the remains of a colliery and a determined group of people who will not let the world forget that at its peak 12,000 people were employed in the mining of coal locally. Through the winter trees at Pandy is visible the Gresford memorial, a stark reminder of the colliery disaster. An event so tragic that it has become a part of the local psyche.

Wrexham was established when the Saxons dominated the area, the name deriving from the Old English word for 'river meadow' – wryhtel. Researching this book has helped me realise how the animosity sometimes felt towards England has arisen. The Maelor lords were

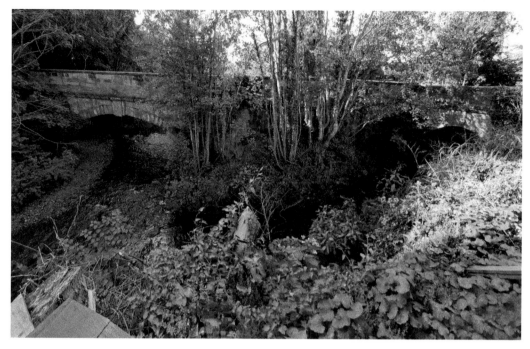

The confluence of the Clywedog and the Gwenfro. The late eighteenth-century King's Mill Bridge used to carry the Whitchurch Road.

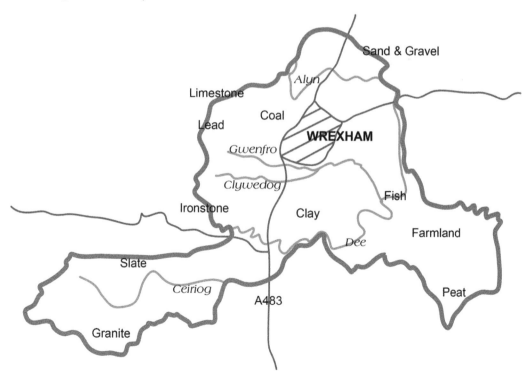

The rivers and resources of Wrexham county borough.

Wrexham is now a hub of international manufacturing.

imposed in the Marches after the Norman Conquest. In the fourteenth century, Edward took control over the Welsh by force. At the start of the fifteenth century, the local Welsh gentry and peasants backed the uprising led by Owain Glyndwr. Its failure was disastrous for Wrexham economically. In the nineteenth century, English coal owners imposed draconian conditions on their Welsh workforce and brought in competing English labour. No wonder the full force of the Wrexham angst is felt on the terraces of the Deva Stadium on derby day. It is with some trepidation I approach this book as an English person. In my defence, I can only proclaim a fascination with the industrial history of the area, extending to nearly forty years; teasing out how the relatively rapid changes in employment happen. My interest led to me

walking old railway lines and canals. Attending heritage openings of old foundries or 'guddling' round the remains of a landscape ravaged by lead mining increased my fascination. I can even boast a visit to the Border Brewery in its 'last gasp'. Wrexham, to me, has an intriguing feel, quite unlike anywhere else.

Now the largest town in North Wales, what gives it a uniqueness? A Welsh identity, yet sitting so close to the English border, it is perhaps more appealing to people from further west than are Chester, Shrewsbury or Oswestry. The town of Wrexham became a focus for these outlying areas. A trading centre with markets, well-appointed hotels, entertainment venues like the Hippodrome and shopping arcades. Understated in relation to its near neighbour Chester but appealing in its 'Welshness', it had a controlled flamboyance at times, thanks to the influence of families like the Soames and the wonderful terracotta of nearby Ruabon.

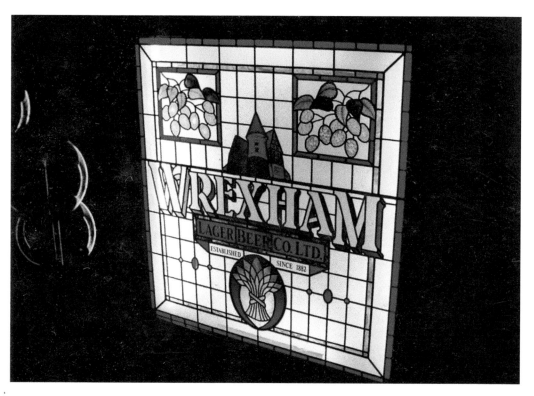

Wrexham Lager Brewery became a vital part of the town's identity. (Wrexham County Borough Museum & Archives)

EARLY DEVELOPMENT

PREHISTORIC TIMES

There is evidence in the form of small flint tools, known as microliths, found near Borras, that people were at work in the area following the end of the last ice age, around 8000 BC. During this period, known as the Mesolithic, people were nomadic hunter-gatherers, at times moving through the wooded landscape of the area using the rivers.

Later in the Neolithic period (c. 4300–2300 BC) people started to settle in farming communities and work at crop growing and animal husbandry. They built the first communal structures using stone – monuments known as long barrows. They started to clear the woodland using stone axes, examples of which have been found at Darland, Borras and Johnstown. They worked stone, made pots, and carved bone with a level of skill rarely matched today. Knives, scrapers and arrowheads were flaked from flint. Pottery bowls were made for cooking, storing and serving food. Bone was used as a material to make objects and tools requiring a point or a sharpened end of all sizes, from pins to spades. Appearance was important, even quite basic objects were carved and polished making them aesthetically pleasing as well as functional.

In the Bronze Age (2300–600 BC) people left behind more evidence of their lives: cairns in the Ceiriog Valley, barrows in the Maelor and two burial mounds, Hillbury and Fairy Mount in Wrexham itself. A burial using a stone coffin was found at Brymbo, containing a beaker pot and flint evidence of local manufacture and wider trade. Hoards and finds in the Alyn Valley reveal that the valley was on an important communication and trade route with Ireland.

EARLY INDUSTRY

The recent discovery of a civilian settlement at Plas Coch suggests some local habitation in the Roman period. Coins found there date it from the period around AD 150 to AD 350. Excavations revealed evidence of developed agriculture and pottery manufacture. The remains of two grain-drying kilns were found. The Romans had also established a large workshop producing tiles and pottery at Holt. The workshop was at peak production supplying the 20th Legion from AD 87 to AD 135, and pottery production continued into the third century. To the north of the borough, at the settlement at Ffrith, a road into Wales was built. It is possible the Romans mined lead at Minera and used this road to transport it.

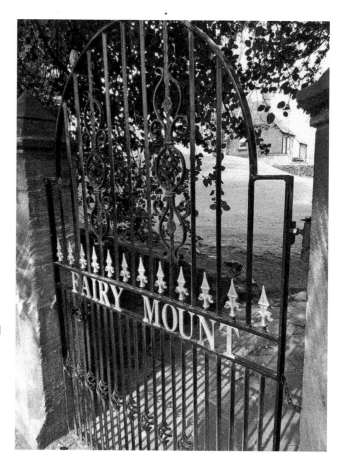

Right: The barrow on Fairy
Road has evoked Welsh
folklore – hence the road and
property's name.

Below: Model of the Roman
brick and tile works at
Holt. Seven kilns have been
discovered during excavation
work. (Grosvenor Museum)

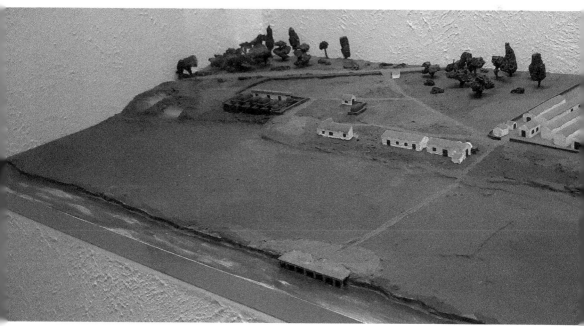

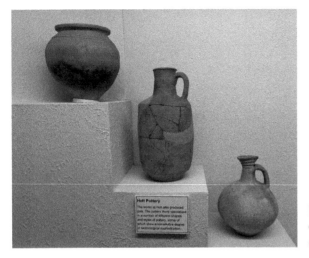

Roman pottery made at Holt during the period AD 85–135. (Grosvenor Museum)

Certainly, people have mined for metals at Minera since at least medieval times (the English name comes from the Latin for mine or ore). The first written reference to mining there dates back to 1296, when local miners were sent to Devon by Edward I to work his silver mines. Mining at Minera has often been problematic throughout the centuries. Black Death decimated the labour force in the fourteenth century and Glyndwr's uprising unsettled the English mine owners at the start of the fifteenth century. Early mining at Minera was constantly difficult due to the flooding problems. Despite these difficulties, Minera was busy from early days. In addition to mining for lead, lime burning is recorded from as early as 1620, providing evidence that limestone was quarried and processed there too.

To the west of Wrexham, in Brymbo and Coedpoeth, the freemen of Holt were given the rights to mine coal from 1411. Coal was mined on a larger scale near Chirk when Black Park Colliery opened in 1653. During the early seventeenth century the Grosvenors and Myddeltons began extracting iron and lead in the county borough. They set up the Pont-Y-Blew forge near Chirk in 1634. The county borough was rich in all the constituents for making iron, so it was logical that by the mid-seventeenth century there were blast furnaces at Bersham, Ruabon and Plas Madoc supplying forges such as the Pont-Y-Blew. The early eighteenth century saw the development of the iconic Bersham Ironworks, which switched from smelting with charcoal to coke in 1721. Charles Lloyd, an associate of the Darbys of Coalbrookdale who had pioneered the production of iron using coking coal in 1709, built a new blast furnace at Bersham in 1717. In the 1730s, Bersham ironmasters started to make cast-iron goods like cooking pots. It was a challenging trade. The price of iron fluctuated, and as a result the ironworks had a series of owners.

Wrexham as a settlement grew up on the flat ground above the meadows of the River Gwenfro in Saxon times, and prospered later during the fourteenth century. The town's market day was on Thursdays and all the people of the local area (the Maelor lordship of Bromfield and Yale) were required to sell their produce through this market. Wrexham's markets and fairs made the town central to the economy of North Wales. Farmers' wives sold poultry, eggs, butter and vegetables on Hope Street; the butchers traded from Abbot Street; and High Street was for the craftsmen's stalls. Traders came from Birmingham, Manchester and Yorkshire to sell their goods, especially during the important March fair. Newcomers were attracted by the town's economic opportunities. The woollen and leather industries were booming. There was enough money around for a bard, a jester, a juggler, a dancer and a

goldsmith to earn their living here. The social and political system governing work was feudal. People paid taxes and gave loyalty and service to the landowner or lord in return for use of land. Local men had opportunities to serve as soldiers in Scotland and France. The pay was better than that available locally and they were sought after because of a reputation for bravery on the battlefield.

The rivers were a source of water and power. In medieval times King's Mill and Felin Puleston corn mills were built on the Clywedog, milling for the townships of Wrexham Abbot and Regis respectively. Nant Mill was further upstream. Meanwhile, in the sparsely populated Maelor Saesneg, colonisers were clearing the woodland and building moated houses.

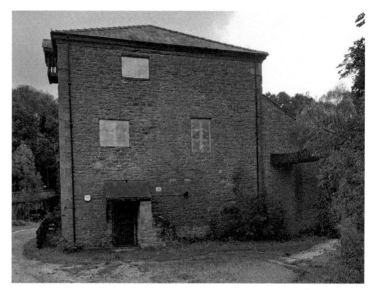

King's Mill was the Crown corn mill for Wrexham Regis from 1495 to 1790. The current building, dating from the eighteenth century, was rebuilt by Philip Yorke and closed in 1940. Latterly, water was supplied by a mile-long leat to a long, thin pond and then into the mill along the high channel on the right.

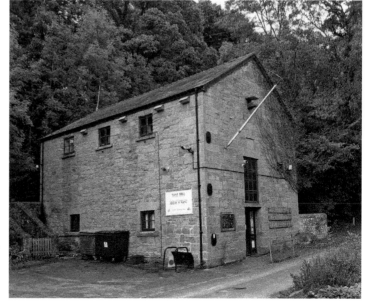

Upstream from Wrexham was Nant Mill, built in 1832 to grind corn on the site of a medieval fulling mill. The Evans family (with ten children) lived on a nearby farm, working both it and the mill from 1889 to 1930.

INDUSTRIAL REVOLUTION

An explosive transformation of the Wrexham economy – from being based on agriculture to one based on industry – took place in the period between 1760 and 1820. The population grew dramatically as the Industrial Revolution drew workers to the Wrexham area, serving the rapidly developing mines, quarries and works. The rivers had been the lifeblood of the area since early times, watering crops and livestock, powering corn mills and driving industrial machinery. At the beginning of the Industrial Revolution the Clywedog was truly the powerhouse of the area. Seventeen mills with different purposes operated along its length: fulling (for cloth), grinding (of corn and malt), and making paper. Huge waterwheels powered the bellows, blasting air into the iron furnaces at Bersham, and drove winding and pumping machinery in the lead mines. Over the course of this period steam power took hold and new industries no longer needed to be sited close to the river.

Immediately prior to the Industrial Revolution, in 1753 the Wilkinson family gained a foothold in the area. Isaac Wilkinson (1695–1784), a north country ironmaster and inventor, keen to find an ironworks with potential, took over Bersham Ironworks. He developed the site, building a water-powered blowing machine and a steam pump for feeding the waterwheel. A tramroad was constructed, bringing iron ore to the works from Ponciau. The main products were pots, pipes, rollers, and armaments. He was said to be a good innovator but a poor businessman and was in financial trouble by 1761. However, his son, John (1728–1808), who took over in 1761, had a shrewd business acumen and was a prolific inventor of new products and processes. John had received a good education and served an apprenticeship in the iron trade. In 1774, John admitted his brother William to a partnership. Their working relationship was complex and eventually they were in serious dispute, William raising a gang to destroy Bersham Ironworks.

John's development of a machine to bore cylinders at Bersham led to the ironworks being well known for manufacturing guns and cannon. James Watt had tried unsuccessfully for several years to obtain accurately bored cylinders for his steam engines. Lateral thinking led to the boring machine being used to make cylinders for Boulton and Watt's steam engines. John Wilkinson entered into a partnership with Watt to make the cylinders. However, Watt's son, also called James, who later ran the business, discovered Wilkinson had been marketing his own unauthorised steam engines. The partnership was terminated. In 1793, Wilkinson

bought a hall and estate at nearby Brymbo and built a blast furnace there, at what would later become Brymbo Steelworks. John Wilkinson arranged to sell Bersham, moving much equipment to his new works at Brymbo.

Another well-known ironmaster, William Hazledine (1760–1840) from Shropshire, bought the Plas Kynaston estate at Cefn Mawr for its coal and limestone. In 1803, he built a foundry there, where among other jobs the forging took place of the iron decking for Pontcysyllte Aqueduct, the Waterloo (Betws-Y-Coed) and Menai bridges and the Scottish bridges at Bonar and Craigellachie.

There was a never-ending demand for food to feed the rapidly increasing workforce. The fertile Clywedog floodplains had always provided rich pasture and corn, but, to meet the increased demand, new corn mills were built and additional areas of woodland were cleared for growing crops. Purpose-built market halls were built in the late eighteenth century: Jones's Hall on Queen Street for linen and fancy goods and Yorkshire Square, below St Giles's Parish Church, for the cloth dealers.

Wrexham's traditional trades – brewing, leather and wool production – had been small scale and linked to agriculture. In the late eighteenth century, they became more industrialised. The town's first commercial brewery opened, and John Peers founded a sheepskin factory, which became the Cambrian Leather Works.

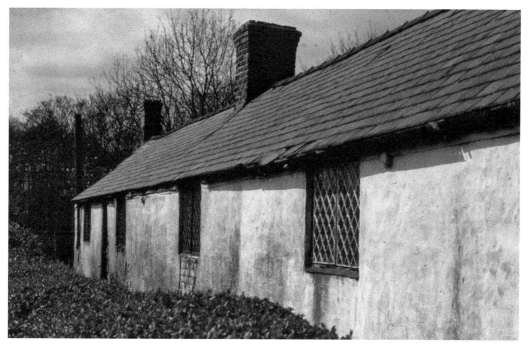

The two surviving houses in a row of thirteen, built at Bunker's Hill around 1785 for workers at Bersham Ironworks. The design for these single-storeyed cottages is thought to have been introduced from Shropshire, where Wilkinson also had industrial interests. It is thought to be one of the earliest rows of industrial houses in Wales. The houses are single storey with brick walls and a pitched slate roof. They are one room deep with rear extensions added later. Each house originally had a two-room plan, with stacks on each gable end. The doors are flanked by small two-light casement windows with heavy latticed iron glazing bars. (Wrexham County Borough Museum & Archives)

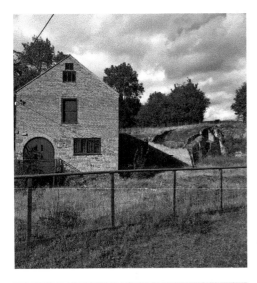

The Bersham boring mill (later converted into a corn mill) and a blast furnace.

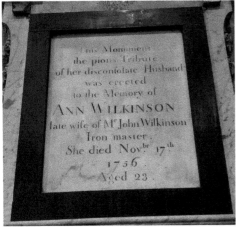

Ann Mawdsley married John Wilkinson in 1755 and moved with him to Wrexham. She died a year later in childbirth and left him enough money to start his own business.

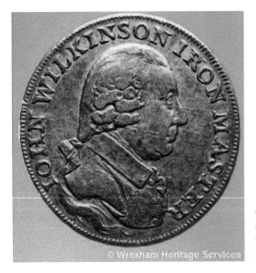

A Wilkinson company token, worth half a penny, made at Matthew Boulton's Soho Mint. (Wrexham County Borough Museum & Archives)

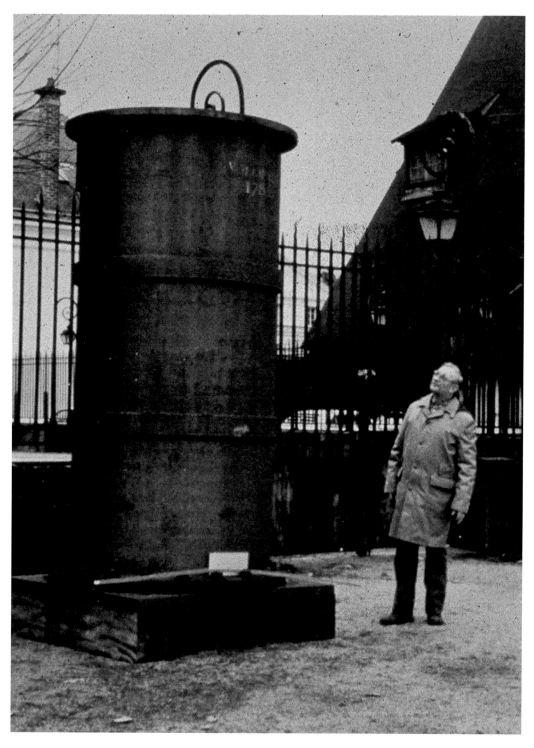

Wilkinson cylinder made at Bersham, delivered to Le Creusot Montcenis in eastern France. (Wrexham County Borough Museum & Archives)

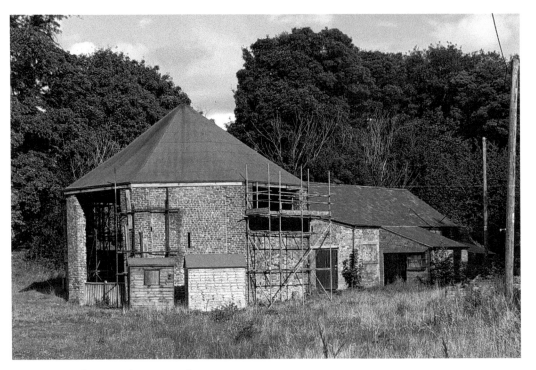

The octagonal cannon boring works.

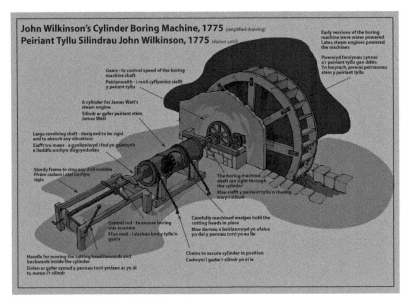

Wilkinson's method for boring cannon was different from earlier ones in three ways. It started with a solid piece of iron, not one cast with a core. The shaft holding the cutting tool was supported on both ends, unlike the cantilevered borers previously in use. The cylinder being bored was turned, not the drill. The American War of Independence (1775–83) and the Napoleonic Wars (1803–15) created great demand for Wilkinson's cannons. (Wrexham County Borough Museum & Archives)

Wilkinson's Penrhos engine house of 1794, the earliest surviving in Wales, housed a beam engine for pumping water from a coal mine on the Brymbo estate. In the 1840s, it was converted into a three-level cottage with window openings inserted above the basement and two domestic-type brick chimneys. The building is now roofless. In plan, it measures approximately 7 yards square and the bob wall, adjacent to the capped mine shaft on the south-east, is 1 yard thick.

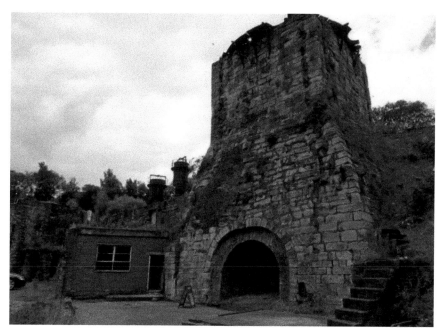

Wilkinson's first blast furnace, later used as a sand hopper, is now being preserved.

EXTRACTIVE INDUSTRIES

COAL

Coal was the source of power that transformed Wrexham from a market town into the industrial centre for north-east Wales. Villages like Rhos, Ponciau and Llay grew up as the industry expanded in the nineteenth century. In its heyday in the 1880s there were thirty-eight collieries employing over 12,000 people around Wrexham, and coal production topped 2.4 million tonnes every year. The abundant supply of coal nearby potentiated the growth of the local iron industry from the mid-eighteenth century. Other industries such as the brick, tile and terracotta works of Abenbury and Ruabon also greatly benefitted. In the twentieth century the huge Shotton steelworks were supplied with Bersham's coal.

The North Wales Coalfield was divided between Denbighshire and Flintshire. Much of the former lay within the Wrexham borough boundary. On the western side the coal measures were nearer the surface, so it was known as the 'exposed' field. The deeper measures were to the east, dipping under other geological layers and known as the 'concealed' field. The earlier mining took place in the west, often using bell pits. Deeper pits were dug later to the east as technology allowed. At 3,000 feet, Llay Main No. 1 shaft was the deepest in Europe. By 1947 there were only six collieries still operating in the field: Bersham (the last one to close, in 1986), Hafod, Gresford, Llay Main and Hall and Ifton.

Tom Ellis in *After The Dust Has Settled* gives an insight into how work in the coal industry was respected in past decades. He himself worked in four of the local pits, and managed two from the late 1940s to the 1960s. It is surprising, given the view of general negativity about the industry today, to hear Ellis's comments. His thought about his ambition to become the manager at Hafod Colliery was 'what could be nobler'. He described how he and fellow students were frustrated at having a day in the classroom rather than starting immediately at the coalface. He is almost poetic at times in his descriptions of the work: 'The river of coal falling from the face onto the main gate belt, like a black waterfall tumbling over rocks, was an enchantment to a young fireman on his first shift.'

Gresford, one of Britain's worst coal mining disasters, took place in the Denbighshire field. The disaster occurred in the early hours of 22 September 1934, when an explosion and underground fire killed 266 men. A controversial inquiry into the disaster did not conclusively identify a cause, though evidence suggested that failures in safety procedures

and poor mine management were contributory factors. Further public controversy was caused by the decision to permanently seal the colliery's damaged districts, meaning that only eleven bodies of those who died were recovered.

Former Wrexham & Acton (also known as Rhosddu) Colliery engine house, now used as industrial premises on the Rhosddu estate, Rhosrobin. The colliery was 1,050 feet deep and operated from 1860 until 1924. At its peak in 1918 it employed 934 men.

The Mines Rescue Station on Maesgwyn Road was established by the North Wales Coal Owners Association in 1913 in response to the 1911 Coal Mines Act. It comprised the superintendent's house, humidity gallery, training chambers, an aviary for the canaries and a garage for the rescue vehicle. The station, a complex of buildings with a fine façade in orange and grey brick, closed in the 1980s. It became the North Wales Fire and Rescue Services HQ and training centre.

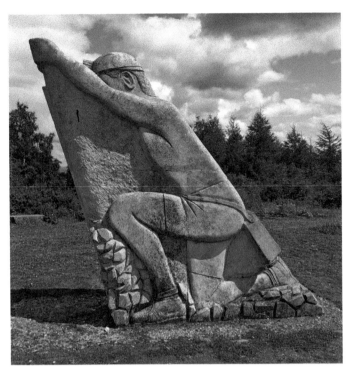

Bonc yr Hafod Country Park lies on the site of Hafod Colliery, which once employed over 1,900 local people, mainly from the villages of Rhos, Ponciau and Johnstown. The sculpture powerfully represents their toil.

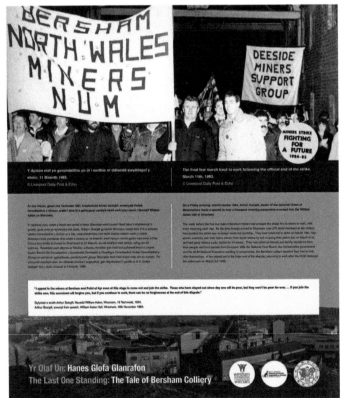

The final few march back to work following the official end of the strike, 11 March 1985. (Wrexham County Borough Museum & Archives)

Llay, built in the 1920s, was the only purpose-built miners' village in Wales. It was conceived as a 'garden city development'.

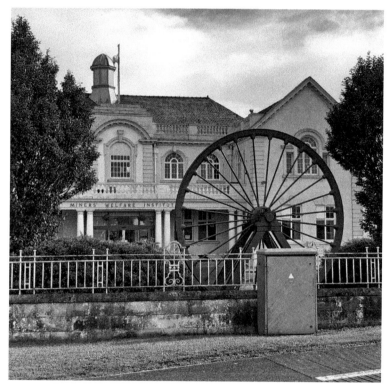

Llay Miners Welfare Institute was originally set up in 1929 and funded by contributions made by miners paying a penny per week towards the cost of construction. The institute offers football, cricket, bowling green facilities and a social area. There is a small museum that gives an insight into the life and work of miners and the mining industry in and around Llay. It is now a Grade II listed building.

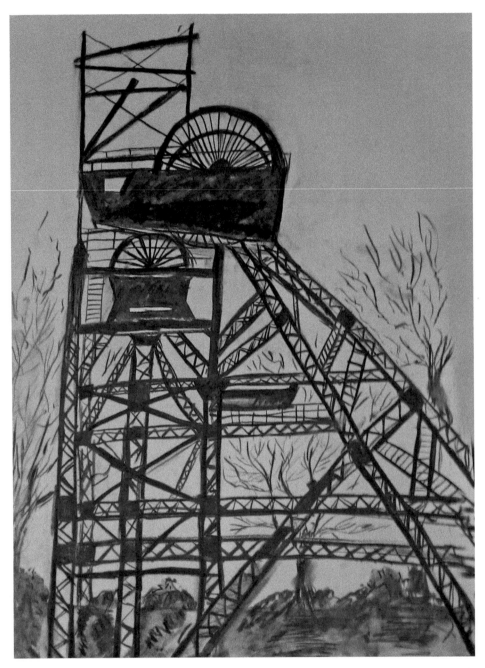

Bersham Colliery's headgear for the 1,270-foot-deep No. 2 shaft. The headgear, the last still standing in North Wales, was brought to Bersham Colliery in 1930 from Gatewen Colliery after a fire destroyed the original timber-built structure. Bersham began in 1868 with the sinking of the first shaft on what was then an old brickyard. An explosion in 1880 killed nine workers. By 1902 the original owners, the Barnes family from Liverpool, employed 675 men below ground and ninety-four more at the surface. Bersham was the last working colliery in the Denbighshire Coalfield, closing in 1986 with the loss of 480 jobs. (Artwork: Karolina Adamska)

Right: The cage was used to wind people and coal tubs up and down the shaft.

Below: Roger Squire in the engine house at Bersham, which he remembers being kept in pristine condition when in operation. He worked underground as a miner for thirty-one years in six pits, with twelve years as a deputy at Point of Ayr. He graphically described the physical effort in working a heavy coal-cutting machine at the face.

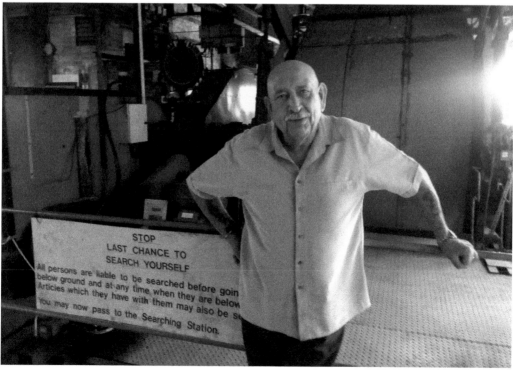

STOP
LAST CHANCE TO
SEARCH YOURSELF
All persons are liable to be searched before goin
below ground and at any time when they are below
Articles which they have with them may also be se
You may now pass to the Searching Station.

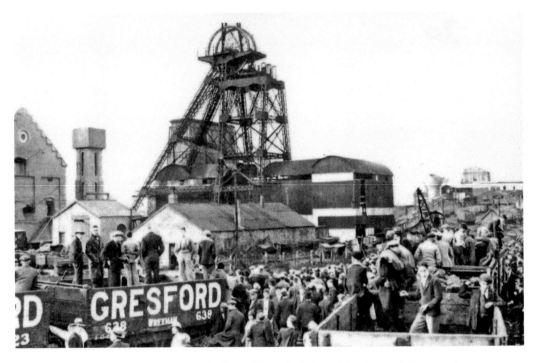

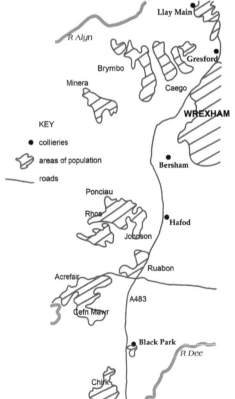

KEY

• collieries

areas of population

roads

Above: Relatives, friends and fellow workers wait for news from underground. (Wrexham County Borough Museum & Archives)

Left: The last collieries in Wrexham county.

LEAD

Visiting Minera, you are aware of the vast bulk of the moor behind. The rainwater cascades from it through the porous limestone holding the veins of lead. Pumping water out in the early days of mining was problematic, but a solution was found when industrial 'giant' John Wilkinson moved into lead. In 1783, he erected the first of seven steam-pumping engines, allowing the larger-scale and regular extraction of lead to take place. However, it was at this time that the problem arose in relation to Watt's patent on the engine, which led to a decline in mining at Minera over the next few decades. The West End mines closed in 1816 and the East End in 1824.

In 1845, John Taylor & Sons, experienced mining agents from Flintshire, formed the Minera Mining Company, consolidating the leases for eleven mines. They saw that Minera had potential, putting in a new drainage tunnel ending near Nant Mill and investing in new pumping engines together with a railway connection. In 1852, lead ore was once again being mined at Minera. New reserves of lead were found deeper underground. The Taylors had started with £30,000 to invest in their mining venture, and the profits for 1864 alone were over £60,000.

It is known that between 1877 and 1882 there were 200–290 staff at any one time who performed a number of tasks. One role was as a timberman, whose many tasks included shoring of loose ground, making and fixing ladders and laying rails for the tramways. Additionally, he helped to maintain the pumps, pipes and associated equipment. At times when staffing was low he was expected to work on the ore crusher too. Men usually worked six hours a day (excluding breaks), six days a week and received no paid holidays. At the end of the era of

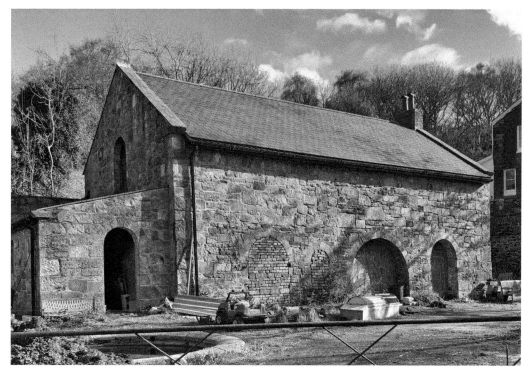

In 1792, Wilkinson built the Brymbo lead smelter to process the lead brought from his mines at Minera. Collapsed tunnels can be found which conducted the fumes to the higher chimney.

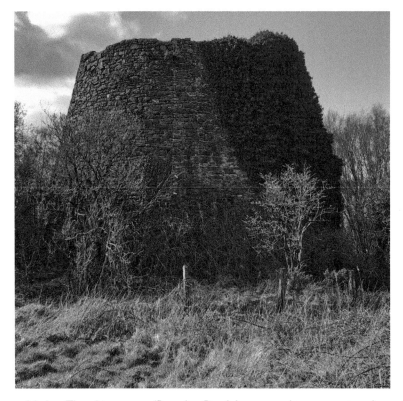

Above and below: The chimney or 'Brymbo Bottle' was used to extract and condense poisonous fumes from the smelter. In the process, lead oxide was produced. Hot air from the furnace in its central core sucked gases along the tunnels.

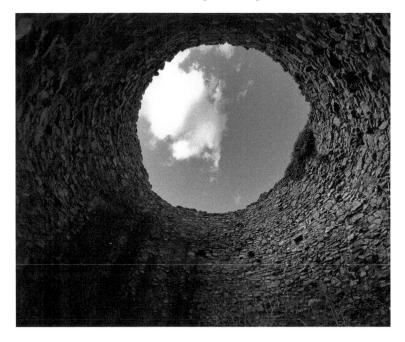

mining at Minera, a miner earned up to 4s 6d a day. It was a dangerous occupation, particularly at Minera. Between 1873 and 1914, twenty-six miners at Minera were killed. Four died at Meadow Shaft in 1901 when the cage plummeted down the shaft. The fatality rate was twice that of the comparable mine at Talargoch, Prestatyn.

The reopened mines did well into the 1870s, but there were problems ahead. The price of lead started to fall, while the price of coal, needed for the pumping engines running, rose. Reserves of lead were starting to run low. Zinc, the other metal mined at Minera, also fell in price. This meant that by the late 1890s, the 'writing was on the wall' for mining at Minera. It kept going for some time, but in 1909 the mining company decided the pumping engines were too expensive to run. The mines started to flood, but it was five years later in 1914 that the mining ceased.

Mining left enormous spoil heaps, which up until the 1950s were worked for gravel, leaving a toxic landscape with heavy metals like lead, zinc and cadmium posing a threat to water supplies and public health. Wrexham Maelor Borough Council and the Welsh Development Agency carried out a reclamation scheme, which started in 1988.

Remains of the Minera Halvans plant built by the John Taylors & Sons mining agents between 1872 and 1874 to extract lead ore from existing low-grade ore or waste heaps in the area. The plant included a beam engine, primary and secondary Cornish crushers, jigs, ore bin, boiler house and six buddles. The excavation of the site was carried out in 1988 by Wrexham Maelor Borough Council as part of the area reclamation work. The site was recorded by Clwyd-Powys Archaeological Trust in 1989 and has been back-filled to protect the structural remains.

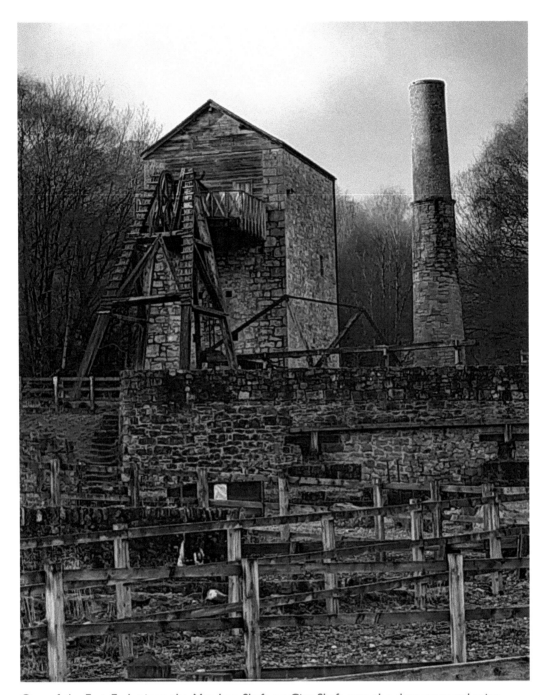

One of the East End mines, the Meadow Shaft or City Shaft, was the deepest metal mine in north-east Wales at 1,220 feet. It prospered in the eighteenth century and again in the mid-nineteenth, later becoming a dumping ground for the nearby Roy's Shaft. The dressing floors became buried, but the shaft remained in use for pumping until 1914. Reclamation in the 1980s restored the engine house and the dressing floor and installed replica machinery. Landscape Trust now arrange open days.

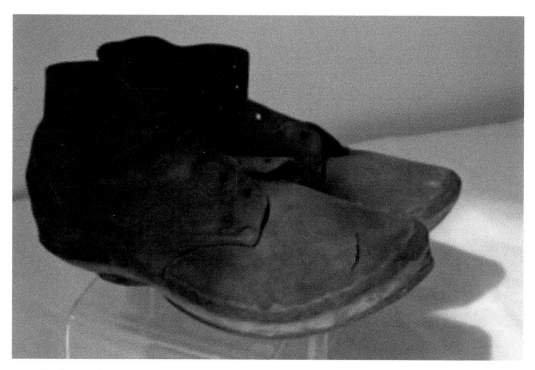

Evidence of the old lead mining industry was found hidden beneath the spoil heaps, including miners' personal belongings such as these clogs.

LIMESTONE

The Minera lime works were once the largest in North Wales. The total output from the supplying quarries was estimated in 1859 to be around 270,000 tonnes, with 200,000 tonnes of this converted to lime. They were operated by two companies, the Minera and the Lester. In 1865, the Minera went public, which raised money for the more technically advanced Hoffman kilns. In 1901, the two companies were amalgamated. The quarries were rail served and had an internal rail system with their own locomotive and 212 open coal wagons and closed lime wagons at its peak. In the early twentieth century the quarry saw varied fortunes, closing in 1933. It was reopened in 1954 by Adam Lythgoe, but closed again in 1972. The branch railway line from Wrexham was pulled up at around the same time. The blasting and quarrying of limestone was continued at the site by Redland plc until 1993. In 1997, Lafarge plc took over Redland and the quarry. For many years since closure the quarry served as storage for road-building materials, and a loading chute for them was built but soon abandoned. In 2004–05, the quarry was subject to a clean-up of all standing materials and the whole area flattened. Tarmac (a supplier of materials to the building trade), who had taken interest in the site took several core samples and found the quarry to still be a viable source of lime. However, Lafarge had no interest in resuming quarrying operations at the site here. An environmental group negotiated with Lafarge about the future of the site and the Minera Quarry Trust was established in 2005. The explicit aim of the trust was to conserve the former quarry site for the benefit of the public and develop it as a nature reserve.

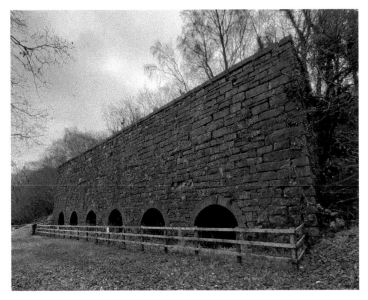

A well-preserved bank of six limekilns of the continuous vertical type and of exceptional scale. Built by the Minera Lime Company in 1852, it is rare to find a bank of kilns like this still extant. There are six drawing arches to the front, each some 10 feet high built of dressed stone. The kiln bank is built of large, randomly coursed rubble, rising to a height of some 50 feet.

The remains of the Hoffman kiln (No. 1) without its 275-foot chimney. It was built in 1868 and used until 1929. It has twenty-four chambers, each of which would hold 109 tonnes of limestone. The central fire could be kept going continuously and the arches worked sequentially. It is one of three that were purpose-built for lime burning left in the UK. The others are located at Langcliffe, Yorkshire and Llanymynech, Shropshire. Originally, the kilns were patented for brickmaking and adapted for lime burning.

In 1859, 181,437 tonnes of lime was carried away by rail from Minera quarries; the Great Western Railway (GWR) hauled out three trainloads daily in 1887. The Minera Limeworks Company owned 212 railway wagons. Output was vastly reduced by the 1960s when this pannier tank loco with only three wagons leaves the quarry area. (John Strange)

Hornby Railways and Dapol have both produced models of the Minera limestone wagons.

MANUFACTURING

BRICK AND TILE MAKING

Mention has been made of the first industrial use of clay in the county borough by the Romans at Holt. Small-scale pottery production took place in medieval times. However, in the eighteenth and nineteenth centuries production of pottery, tiles, bricks and terracotta items became one of the major sources of work. Manufacturing techniques improved, with blended clay, better moulding and more even firing, which led to greater consistency in shape

Henry Dennis's giant Red Works at Hafod became the last of the clay works in the county borough to make ridge tiles, chimney pots and decorative items. In 1944, Dennis's grandson, Patrick Gill Dyke Dennis, took control and launched a modernisation programme. However, by the end of the 1970s, brick production had largely ended and the company concentrated its efforts on making quarry tiles. A small section is now operated by Ruabon Sales Ltd producing floor tiles in a modern kiln.

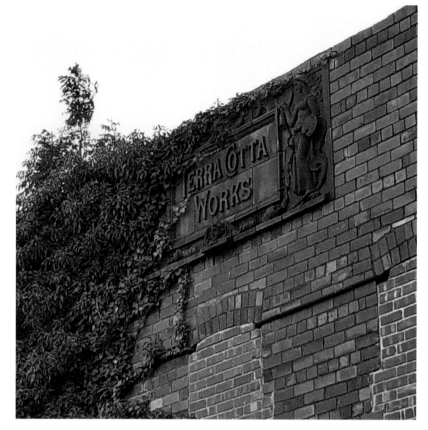

Right and below: Making sure everyone knew the Red Works' owner and purpose!

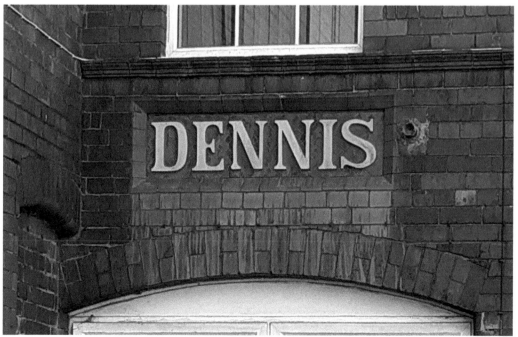

and size. The Ruabon area had a huge bed of quality marl clay, which extended in part to the south of Wrexham. Its extraction in the nineteenth century heralded the beginning of tile and terracotta production on a vast scale. Henry Dennis, an ambitious engineer from Cornwall, moved to North Wales in the 1850s and established himself as a giant of the industry. In 1878, he took over a failing brickworks at Hafod Colliery, 3 miles south-west of Wrexham. He transformed it by building a new works in 1893. The Red Works became a world leader in the design and manufacture of a wide range of hardwearing and decorative bricks, tiles and terracotta items. Dennis was a major employer with interests in quarries, collieries, lead mines, waterworks, brickworks and the Glyn Valley Tramway. His company's head office was on the High Street in Ruabon. The firm flourished in the building boom of late Victorian and Edwardian Britain (1880–1914). You can still see the finest Dennis Ruabon brickwork on many buildings in the North West. The company's fortunes mirrored those of the British economy during the twentieth century.

The other major company was J. C. Edwards, established in 1860 with works at Trefynant (Acrefair), Coppi (Rhos) and Penybont. In addition to many UK contracts, they also exported to India, Canada, Singapore and Panama. Additionally, there were numerous other pottery and brickworks in the county borough.

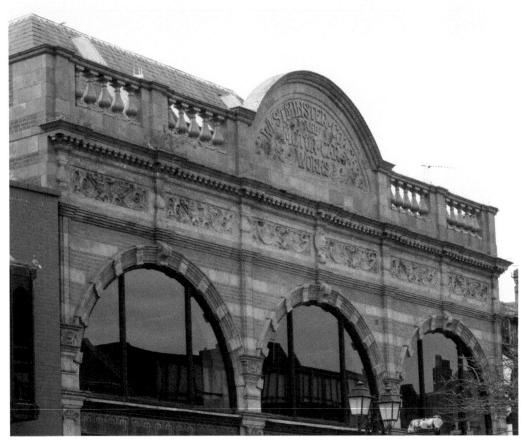

The façade of the Westminster Motor Car and Coachworks in Chester shows a stunning example of Dennis terracotta work.

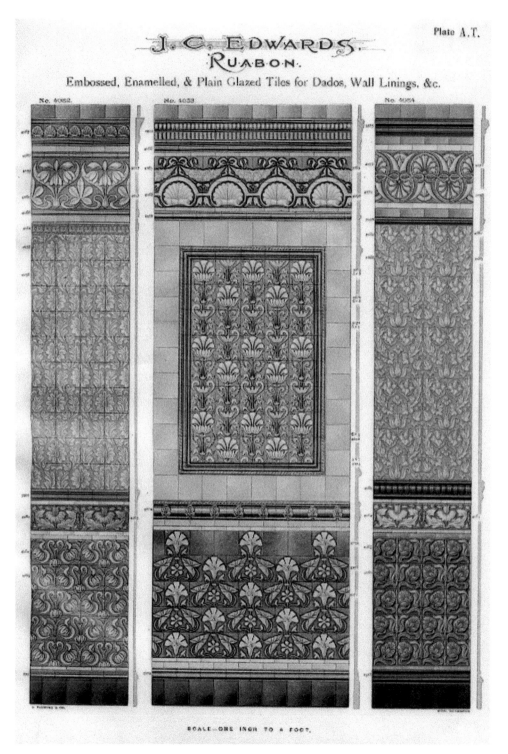

A spectacular display of J. C. Edwards tiles. (Wrexham County Borough Museum & Archives)

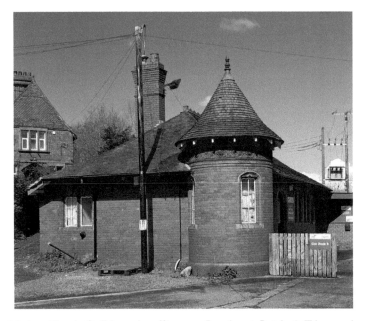

Above and below: The J. C. Edwards offices at Penybont Brick & Tile works showing examples of their work in the lobby.

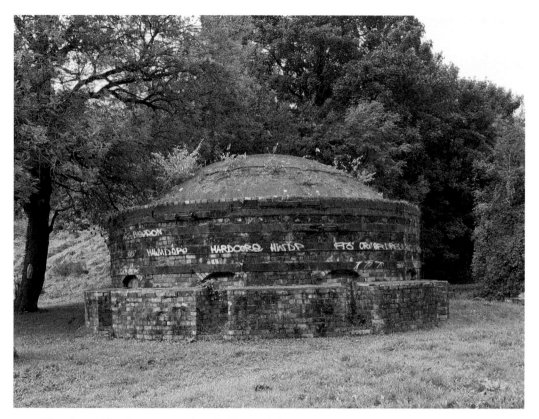

The domed brick structure beside Kings Mill is a beehive kiln that was moved from nearby Davies Brothers' Abenbury Brickworks. Davies Brothers were civil engineering contractors who built the Wrexham & Ellesmere Railway. Their brickyard was established at their main works yard for the WER.

CHEMICALS

In 1867, Robert Ferdinand Graesser, an industrial chemist from Obermosel in Saxony, Germany, established a chemical works with Timothy Crowther at Plas Kynaston to extract paraffin oil and wax from the waste shale of local cannel coal. In 1873, the partnership was dissolved. Graesser set up a new works nearby, initially continuing shale distillation with twenty-nine employees in 1879. The following year, 1880, he started distilling tar acids transported by canal boats from the Midlands to make phenol (carbolic acid). In 1890, Graesser acquired Corbett & Co., and hence expanded into the original Plas Kynaston works. By now he had forty-two employees, and the site soon became the world's leading producer of phenol. Robert died in 1911 and his son Norman took over, the company going public in 1916.

In 1919, the US chemical company Monsanto entered into a partnership with Graesser's chemical works to produce vanillin, salicylic acid, aspirin and, later, rubber-processing chemicals. In 1928, Monsanto took full ownership, with its head office in London, and in 1934 was made a public company. For seventy years it was the major employer in the area, with 400 employees in the mid-1990s. The site was later operated by Flexsys, a subsidiary of Solutia, but production ceased in 2010. A small section of the site continued as Nano Technological Materials.

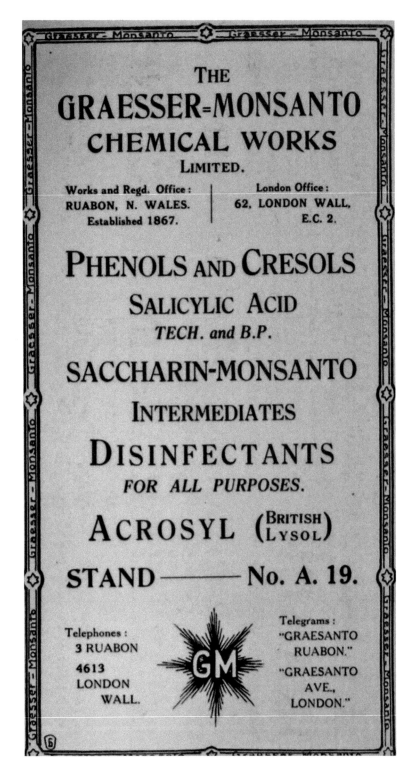

Early Cefn Mawr chemical works advert.

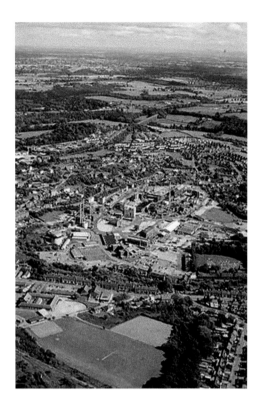

An aerial view showing the huge expanse of
the Monsanto works at Plas Kynaston in the
1970s. (Plas Kynaston Canal Group)

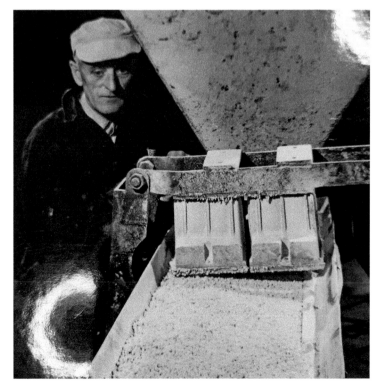

A Monsanto
worker. (Wrexham
County Borough
Museum & Archives)

ENGINEERING

The foundries that developed in towns during the Industrial Revolution had a variety of origins. They also varied in the degree of mechanical engineering skills their staff possessed; some, later in the nineteenth century, developed a formidable engineering skill base. Several of the engineering companies in Wrexham illustrate the differences. Powell Brothers Ltd based at the Cambrian Iron Works were engineers specialising in agricultural work as well as iron and brass founders. The company had started up in 1784 as an ironmongery business. Richard Jones founded the business and eventually his great-nephews John and Robert Powell took over. Joined by Robert Whitaker from Leigh, the company was incorporated in the 1870s. Their prize-winning product range included root pulpers and slicers, chaff cutters, potato lifters, seed drills, mowers and horse gears. In 1914, John Powell's sons took control of the business. In 1915, the company converted the Cambrian Works into a munitions factory. On average 10,000 shells and 1,500 trench mortar bombs were produced every week until the end of the war.

A restored Powell Brother's and Jackson root cutter. (Wrexham County Borough Museum & Archives)

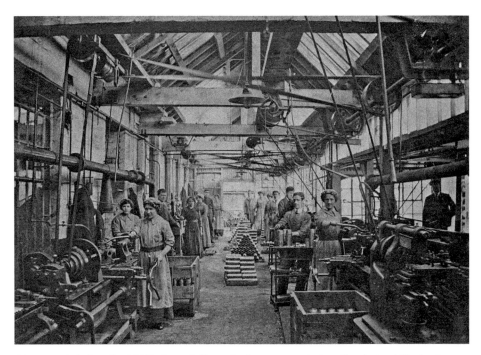

Above and below: In 1915, Powell Bros Ltd converted the Cambrian Works into a munitions factory making shells (seen here in the workshop) and trench mortar bombs. Many of the workforce had volunteered in the first few months of the First World War to join the armed forces. In their place, the company employed women and men who were unable to serve in the forces. (Wrexham County Borough Museum & Archives)

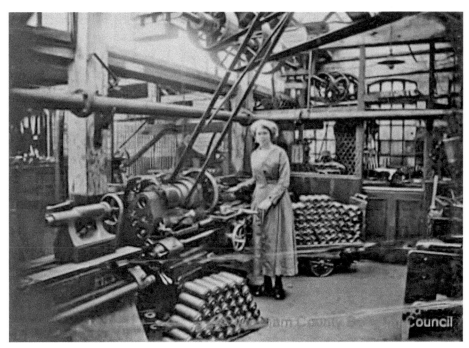

In 1917, Powells launched their stationary oil engine project in order to produce a simple engine to power the farm machines they sold. The series of engines ranged in size from 2.5 hp to 10 hp, and nearly 4,000 engines were sold. They were used to run equipment such as threshing machines, sausage makers, elevators, timber saws and water pumps, or to generate electricity. The company had ambitious plans. They branched into motorcycle production in the early 1920s and established a network of agents throughout the world to sell their products. Unfortunately, their ambitions coincided with the global recession that followed the First World War and as a result the company went into voluntary liquidation in 1925. The engine patterns were sold to Cudworth and Johnson.

Cudworth and Johnson were iron and brass founders and engineers manufacturing and repairing a range of equipment for local industry. Originally established at Stansty ironworks they employed forty people, making everything from engines to girders. They repaired colliery plants, weighing machines and boilers. In 1891, they sold Stansty and bought Eagle Foundry, which had previously belonged to a Mr Chadwick.

Rogers and Jacksons were long-established retailers but took over the Cambrian Works after Powells. They then provided a service and maintenance section for farm machinery, a joinery department that made such things as fencing and gates for housing schemes, and for agricultural use, poultry houses, greenhouses, garages, and portable buildings. After the Second War the company produced around 10,000 gates for prefabs. They were also large contractors for central heating plant, milking, sterilising and lighting plant, and erected light steel buildings for agricultural, industrial, and military use. The company had showrooms in Chester, Abergele, Colwyn Bay, Mold, Oswestry, Shrewsbury and City Road, London. In the 1930s, Rubery Owen & Co, an engineering firm originating in the West Midlands, took them over. There was a previous connection in that Alfred Owen had once been a partner in Rogers and Jacksons. Later Rubery Owen took over a Ministry of Aircraft factory built in 1941 on the Abenbury brickworks site for making axles. This business closed in 1980 and the site is now an industrial estate.

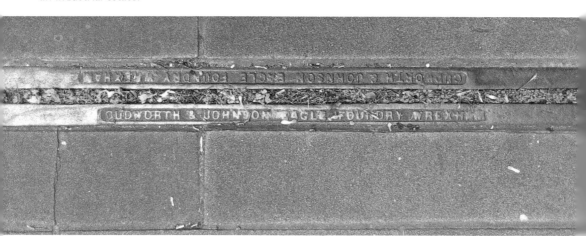

Local ironwork is often evidence of earlier industry. A Cudworth and Johnson pavement-level rainwater gulley.

IRON & STEEL

John Wilkinson oversaw the development of an industrial empire and the establishment of Brymbo Ironworks. It is easy to focus on this site and Bersham, with their history of innovation, and the scale of the Brymbo operation. However, there were also ironworks at Acrefair and Ffrwd, and numerous foundries throughout the borough. The New British ironworks at Acrefair (1817–87), for example, employed 1,500 staff at their peak. On-site they had coking ovens and limekilns and operated the nearby Wynnstay colliery to provide coal.

Diagram 1: Tons of Steel Produced at Brymbo Iron and Steel Works By Year

1796	884 (iron)
1898	30,000
1914	60,000
1932	0
1936	65,000
1950	109,000
1960	143,000
1965	315,000
1990	245,000

Diagram 1 shows that the Brymbo Ironworks entered production in 1796. Wilkinson built a second furnace in 1804 and continued to develop the site until his death in 1808. The ironworks then suffered from probate disputes, the absence of a skilled ironmaster, and a slump in orders after the end of the Napoleonic Wars. The sale of the estate in 1829 provided the opportunity for a new beginning. In 1841, the works and estate were to be bought by Robert Roy, and in 1842 were handed to Henry Robertson, the young Scottish engineer, to develop. Robertson engaged two grandsons of Darby, the famed ironmaster of Coalbrookdale. In the early 1880s, the business was incorporated as the Brymbo Steel Co. Ltd. Robertson encouraged a trial of steelmaking using the open-hearth process in 1883 and by January 1885 had set up a plant using the process, which was the first of its kind in the United Kingdom.

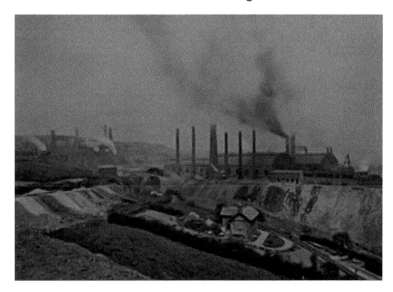

An early view of Brymbo works. (Wrexham County Borough Museum & Archives)

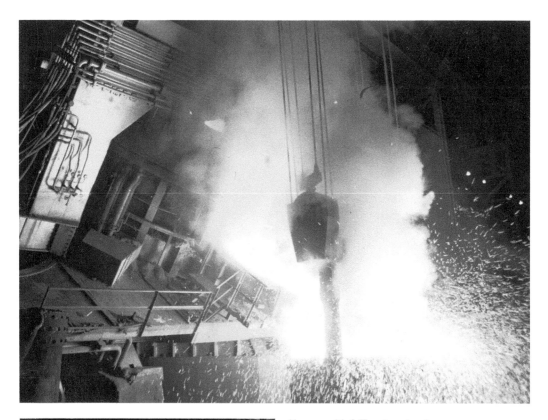

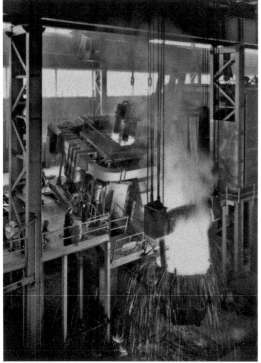

Above and left: Tapping the furnace. (Wrexham County Borough Museum & Archives)

A second downturn of fortunes occurred when the Great Depression caused the works to go bankrupt in 1931. The plant was saved and production restarted by Robertson's son, Sir Henry Beyer Robertson (1862–1948). He negotiated a lucrative contract to supply engineering steel for Rolls-Royce Limited aero engines. Diagram 1 shows production was back on target by 1936. The first electric arc furnace was installed in 1939. In 1948, the company was taken over by Guest, Keen and Nettlefolds. In 1956, a new melting shop was built, with electric furnaces being sited on an artificial hill made from furnace waste. People had to leave their homes in the Lodge area of Brymbo to make way for this new development. Brymbo was nationalised with the rest of the steel industry in 1967, becoming a division of British Steel Corporation. A further expansion in the early 1970s resulted in the construction of a large, modern rolling mill south of the main steelworks site. In 1978, the steelworks took its single automated blast furnace out of use and concentrated on the production of high-quality steels from scrap metal.

As early as the 1960s and 1970s there had been rumours that British Steel planned to close Brymbo. Unfortunately, the new bar and billet mill opened in 1980, just in time for a recession. With falling demand for quality steel from British car makers, Brymbo steel also faced increasing competition from European steelmakers, who enjoyed state subsidies. The workforce at Brymbo Steelworks rose to the challenge; production records in the melting shops and the rolling mills were continually broken with no loss of quality. Although the workers had faith in the steelworks, the new owners, United Engineering Steels, did not. Their decision in 1986 to invest £60 million by installing 'continuous casting' in their steelworks at Rotherham, rather than in Brymbo, heralded the work's future closure. Despite the work's profitability, high productivity and unique quality control systems, UES announced the closure of Brymbo Steelworks on 14 May 1990 with a loss of 1,100 jobs. The last furnace was tapped on 27 September.

During its history the steelworks was involved with or supported a number of other industrial sites in the immediate area, including collieries (with one, the Blast Pit being located within the works itself) and a brickworks at Cae-llo, which produced firebricks until 1975.

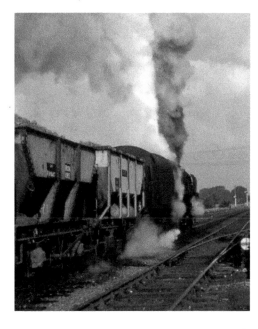

A large British Rail locomotive starts the pull up to Brymbo with iron ore for the works. (John Strange)

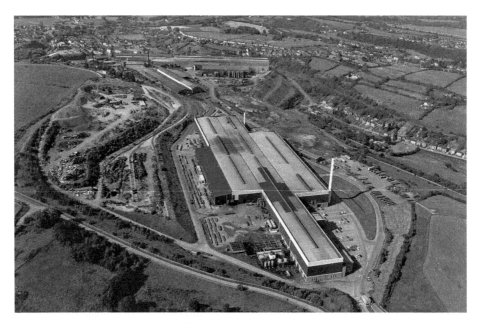

Brymbo steelworks in the mid-1980s. In the foreground is the large, modern rolling mill. In the right background is the 1956 melting shop built on a platform of slag. (Wrexham County Borough Museum & Archives)

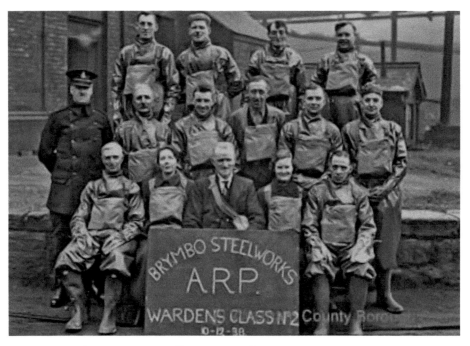

The Air Raid Precautions team. The demand for precision steel rose as rearmament occurred in the late 1930s. This led to new business for the steelworks as part of the war effort after its closure during the Great Depression. (Wrexham County Borough Museum & Archives)

TOWN SPECIALTIES

Most market towns in medieval times had a range of manufacturers producing leather, foodstuffs, textiles and clothing. This continued into the eighteenth century. In the nineteenth century, there was a general transition in the economy from small-scale production to business concentration and industrialised methods of production.

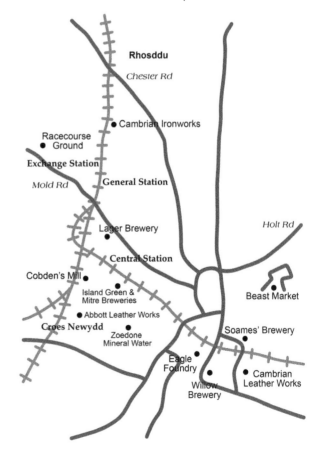

A selection of Wrexham town's industries.

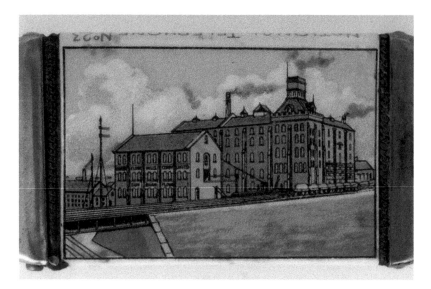

A Cobden Mill enamelled matchbox. The mill was built in 1846 after the repeal of the Corn Laws and named after the anti-Corn Law campaigner. It was the largest commercial premises in town and employed 150 men. The other big local flour mill was the Victoria Mill, which had been converted from a brewery. It burnt down in 1895, a hazard of such mills because of the explosive quality of wheat dust and flour. (Wrexham County Borough Museum & Archives)

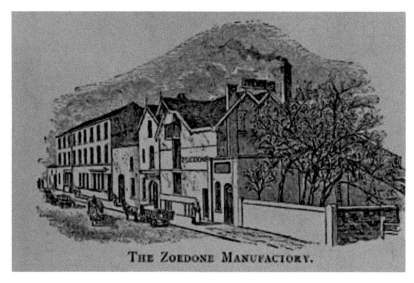

Zoedone Mineral Water Works established in the 1880s at the former Abbot's Mill. The building was later taken over by Hugh Price & Co. and converted into a leather works. Zoedone, together with J. F. Edisbury & Co., supplied aerated, flavoured water. Natural mineral waters were first bottled in the sixteenth century. However, it was not until the 1780s that carbonated water was produced commercially following the development of the infusion process by Joseph Priestley. The first factory was built by Thomas Henry of Manchester. (Wrexham County Borough Museum & Archives)

BREWING

Largely due to the high quality of the local water, brewing became a distinctive local industry. The sands and gravels around Wrexham act as a giant filter for water that builds up on the impervious rocks beneath. Wrexham stands above a fault: to its east there is hard water with a high mineral content suitable for brewing beer; to the west softer water with fewer minerals ideal for lager. Wrexham was still divided into the two townships of Abbott and Regis in the nineteenth century. Nearly all the breweries were in the former, which offered more favourable rates of taxation.

In 1860, there were nineteen individual breweries in Wrexham, of which seven appear to have been small breweries located at pubs. In that year Peter of the Walker 'brewing dynasty' bought Willow brewery from a Robert Evans, having learned his trade there in the 1830s. Walker was ambitious, building a new brewery alongside the original one over a 7,000 square yard site with 140-foot tower. A sign of the times, showing the importance of the industry, was that Peter Walker became mayor for two years, running 1866–68. He obviously took great pride in this appointment, providing the town with a ceremonial mace. However, it is said he was slighted at not being appointed as mayor for a third term and began building another new brewery at Burton-on-Trent in 1882. Perhaps there was better business opportunities in the Staffordshire town? The only link to Wales at his planned Burton brewery was a Welsh goat on the weathervane. He didn't see it completed as he died at his home in Coed-y-Glyn, Wrexham, in April 1882. Continuing to benefit the town, he left £1,000 to help build the national school on Madeira Hill.

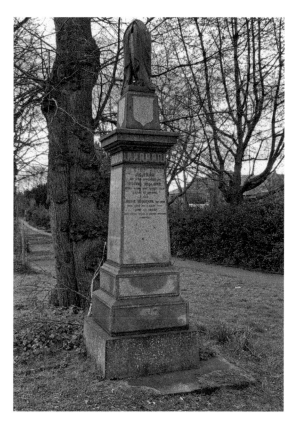

Peter Walker's memorial obelisk in Ruthin Road Cemetery.

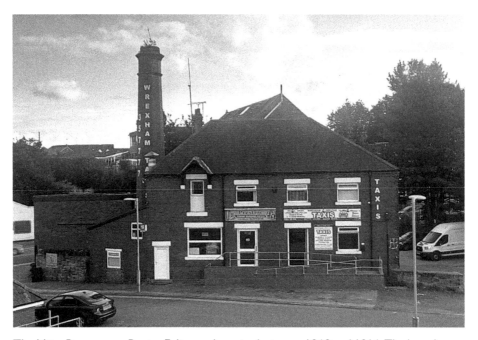

The Mitre Brewery on Pentre Felin was brewing between 1868 and 1916. The brewhouse and its chimney have survived.

By 1909 there were three large commercial breweries: Soames' Brewery on Tuttle Street, Island Green Brewery, and the Lager Brewery. Soames' had its roots in the Nag's Head pub brewery, established 1834 and purchased in 1874 by Arthur Soames. His twenty-one-year-old son Frederick managed it and within ten years had built up the business into a major producer. Island Green Brewery was founded in 1856 by John & William Jones of Caia Farm whose mother was a brewer. Their brewery was built on the site of earlier breweries and substantially extended in 1890. The brothers ran the brewery until 1905, were pillars of the local community and formed a charitable trust.

Wrexham Lager Brewery was founded in 1881 by Otto Isler and Ivan Levinstein – two German immigrants from Saxony – using a supply of suitable water from the Pant-Y-Golfen spring in Maesgwyn. They had technical problems with cellar temperature and went into voluntary liquidation in 1886. Robert Graesser bought a majority shareholding and introduced mechanical refrigeration. Sales were low due to the different style of beer not being popular locally and the company went bankrupt in 1892. An international market was then found by Graesser in the countries around the Empire. The Great Western Railway also served Wrexham Lager in its restaurant cars. The company was acquired by Ind Coope Ltd in 1949, who significantly invested in it during the 1960s. Later, Ind Coope became part of the huge Allied Group, who in turn became part of Carlsberg-Tetley and closed in 2000.

Spurred on by the economic depression, Border Breweries Ltd was formed by the 1931 merger of the Soames, Island Green and Dorsett Owen (of Oswestry) breweries. Brewing was concentrated at the Soames' site, Island Green being used for storage. Border was successful for some fifty years but finally fell victim to the increasing consolidation of the UK brewing industry during the 1980s. In 1984, Marston Thompson and Evershed acquired Border and its 170 tied houses. They were to close the Border site within six months, continuing to produce Border products for some years under the Marston's name.

Above: The Island Green Brewery buildings were listed in 1981, and in the later 1990s converted into apartments. (John Strange)

Right: The Nag's Head pub with Soames's 130-foot chimney (built in 1894) and brewery on Tuttle Street. The latter was the five-storey brewery extension built in the 1920s. The chimney had wrought-iron reinforcing bands and is highly ornamented, with dated terracotta panels containing the logo 'S'. The chimney might have been a tribute to Soames Sr, who died the same year on 28 April (1894) at Llwyn Onn Hall, Abenbury. The chimney, a prominent Wrexham landmark, was purchased by the then local MP John Marek to save it from demolition.

Soames Brewery window in the Cross Keys Hotel, Chester – gone now, sadly.

The Soames logo was a bridled horse's head.

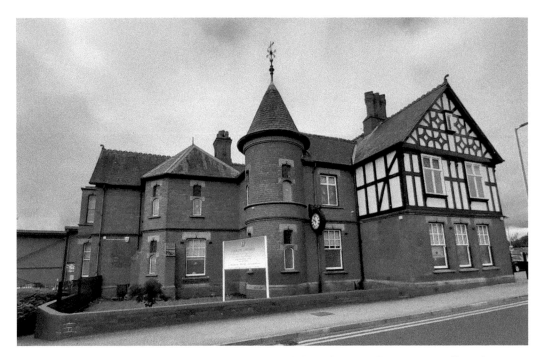

Wrexham Lager's original tower brewery, which later became the company offices. It is now all that remains of the brewery.

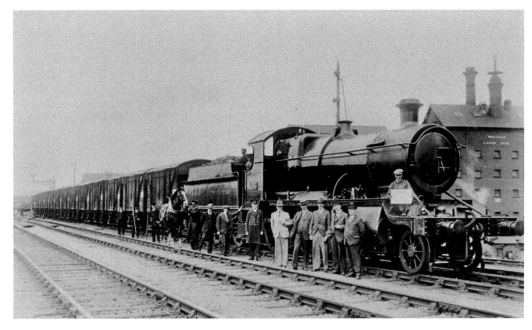

A special train leaving the lager brewery with 1,700 casks for the Cunard Line on 27 June 1931. Lager was not popular locally when first brewed, so an international market was found around the empire. The Great Western Railway also served Wrexham Lager in its restaurant cars. (Wrexham County Borough Museum & Archives)

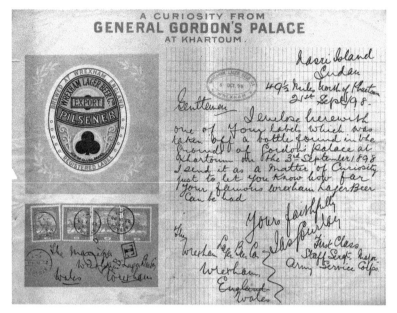

Copy of a letter sent from Khartoum, Sudan, 1898, to the directors of the Wrexham Lager Beer Company. The bottle label had been found in the grounds of General Gordon's headquarters in the Sudanese capital after the relieving force arrived too late to save him. It's possible the soldiers besieged with General Gordon in Khartoum in the Sudan tried to drown their fears with Wrexham Lager before they were hacked to pieces by the forces of the Mahdi in 1898. (Wrexham County Borough Museum & Archives)

Martyn David Jones (on the left) was the brewing chemist at the lager brewery. He became the Labour MP for Clwyd South from 1987 until his retirement at the 2010 general election. (Wrexham County Borough Museum & Archives)

Filling the lager barrels.

A chance meeting on a train between Graesser and Levistein led to the former's involvement in the brewery.

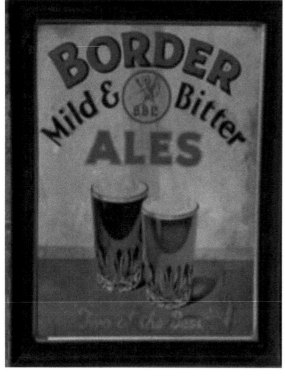

Border, brewed in Wrexham from 1931 to 1984.

LEATHER-MAKING

The tanning process to make leather was first recorded in Wrexham in 1300. Production would have been small-scale then. The carcases would be purchased at market by the butcher, who would take the meat and then sell on the skin to the fellmonger. The fellmonger would remove the wool from the skin, and the bare skins were then sold to the tannery. The tannery process is divided into three fundamental sub processes: preparatory stages, tanning, and crusting. The leather would mainly be used for boots, shoes and riding tack. In the late eighteenth century, Arkwright developed the water frame for spinning yarn, which required soft leather on the rollers. Wrexham became a major supplier as the skins of Welsh upland sheep had the ideal structure to fulfil this application. Locally sourced skins could only supply about 250,000 skins per annum so upland sheepskins from other parts of Britain were also used. By the nineteenth century two leather works dominated the local industry.

In 1858, Charles Rocke and John Meredith-Jones (1832–92) bought the Cambrian Leather Works and continued in business for thirty years. In 1888, the partnership was dissolved and Rocke moved to London. Meredith-Jones was joined by his sons Frank Meredith and Alfred Seymour-Jones, both of whom had served their apprenticeships in leather to form J. Meredith Jones & Sons. At its zenith the company had depots in eighteen countries and 500 workers.

The other large leather producer was Hugh Price & Co. who started in the Bridge Street tannery. They moved to the Abbott leather works in 1904. The works was said to be the only one in Wrexham where the old oak bark system of tanning was used until the end. The whole process from rough hide through to finished product took place on the site. Over eighty people were employed at the works.

Although roller leather was a major product of the two works, they also made fancy leather for items of apparel (boots and shoes, hats, caps and gloves) together with bags and purses. A major contract for the Cambrian Works was for the book binding of the *Encyclopaedia Britannica* in 1945, which required a million skins. The Cambrian Works also specialised in chamois leather from 1945, which was popular on the USA market.

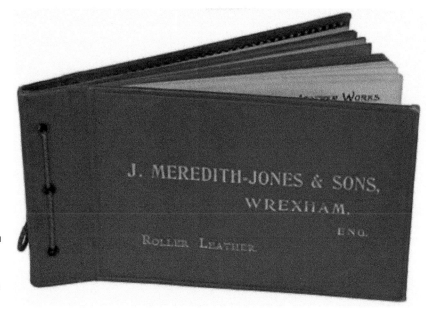

A sampler wallet. (Wrexham County Borough Museum & Archives)

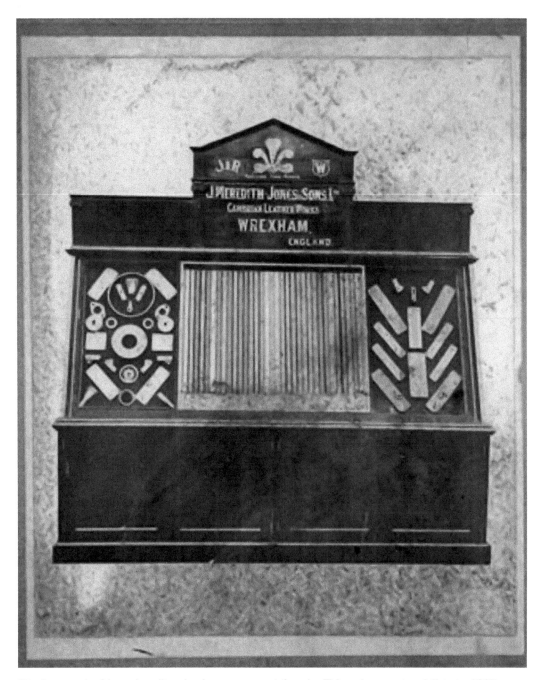

Display stand of Jones's rolling leathers prepared for the Tokyo International Fair in 1907. (Wrexham County Borough Museum & Archives)

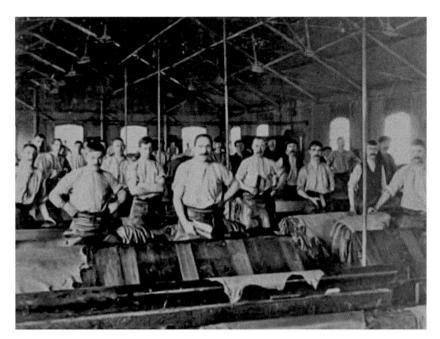

Some of the workers look very young in the finishing room at the Cambrian Works. The drive shaft on the wall powers stone buffing wheels to soften and remove roughness from the leather. (Wrexham County Borough Museum & Archives)

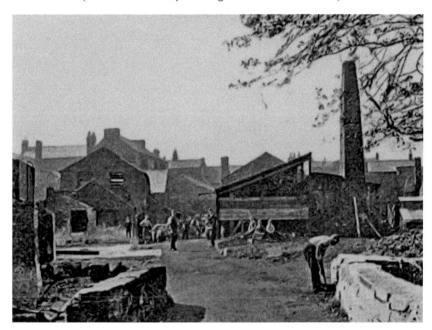

Hugh Price's Bridge Street tannery in 1907. The Bridge Street tannery was said to be the only Wrexham tannery where the old oak bark system of tanning was still used. The whole process – from rough hide through to finished product – took place on this site. Over eighty people worked at the tannery. (Wrexham County Borough Museum & Archives)

THE MAELOR SAESNEG

The lowland to the east of Wrexham town forms a marked contrast to the industrialised valleys to the west. The sinuous Dee is a central feature. The Maelor Saesneg (or English Maelor) is the area to the east of it, extending almost to Whitchurch. Originally thickly wooded, the land was cleared originally and 'sweetened' (made less acidic) by marl dug from pits in the field, a process now carried out by fertiliser and ploughing for appropriate crops (cereals, root crops and rapeseed). Meres and peat filled mosses are also found in the Mealor, a result of the ice mass melting after the last ice age 10,000 years ago.

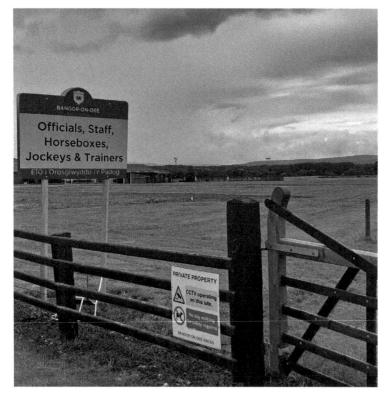

Bangor-on-Dee Racecourse is a left-handed horse jump racing course. Racing first took place at the course in February 1859 and has since taken place regularly except during the wars. Since 2006, Bangor has hosted amateur point-to-point races run by local hunts. The course for the point-to-point is on the inside of the main track and races are run right-handed.

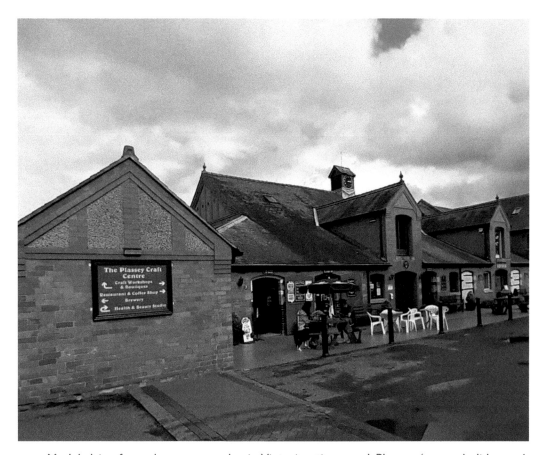

Model dairy farms became popular in Victorian times and Plassey (now a holiday park with retail and business units) is a good example. They incorporated new technology and improved farming methods. This was driven by the needs of the fast-growing population and competition from imports from Europe, the Americas and Australia. The main answer to this problem was seen at the time to lie in 'high farming', a system that worked on the theory that high capital input by both landowners and farmers were essential to achieve the high levels of output necessary to maintain or increase farmers' profits. Plassey Farm was named after the decisive victory of the British East India Company under the leadership of Robert Clive over a much larger force of the Nawab of Bengal and his French allies on 23 June 1757. This led to the establishment of British rule over India for almost the next 200 years.

FARMING

Medieval ridge and furrow gave way to dairy pasture in the area in the early nineteenth century. The many farms supplied a creamery, which was built in 1936 by Cadbury's at Marchwiel. The site was bought by the Milk Marketing Board in 1973 for butter and skimmed milk powder production. Between 1976 and 1992, it was given over to cheese manufacturing. Dairy Crest took over in 1993 and developed it as a cheese-packaging plant with a staff of 485 people. First Milk purchased the plant in 2006.

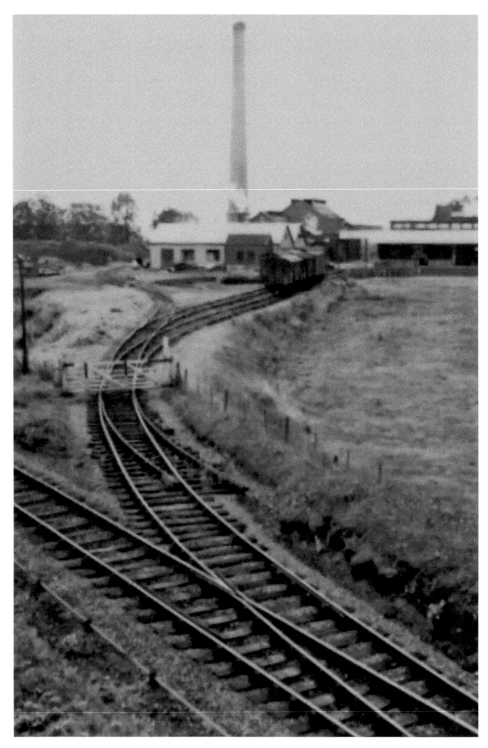

Marchwiel creamery, seen here in 1962, was still rail served from the Ellesmere line.
(C. C. Green/J. M. Strange)

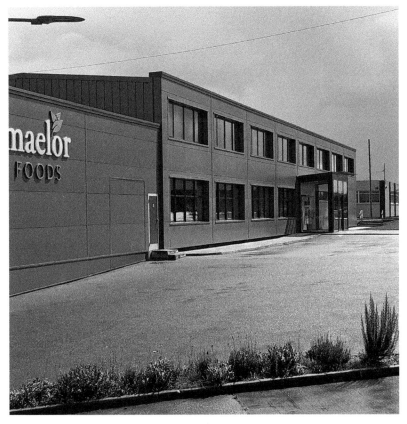

Marchwiel creamery is now owned by Maelor Foods, a poultry processing company originating from Bilston, West Midlands.

FISHING

At times, several hundred coracle fishermen worked successfully on the upper Dee. Two men would fish at night using a net consisting of two layers of hemp or linen stretched between their coracles. The outer layer or 'armour' was coarse and squarely meshed. The inner layer or 'lint' was finer meshed. A huge number of fish were caught. In 1882, for example, almost 11,000 salmon were caught on the river along with more than 600 trout. By the 1890's, however, salmon numbers had reduced, so new stock was added to the river.

Coracles have a long history. They were made from calico, which was stretched over a frame made from ash wood and then covered in pitch and coal tar. The lower Dee model had sharp incurving sides and a broad flattened bows and was designed for one person rather than the upper Dee's two (the boundary was the confluence with the Ceiriog).

There was competition for the stock with the increasing number of sport fishermen. The last three 'nets' were bought out in 1920 for £1,000, which brought an end to commercial fishing on the upper Dee.

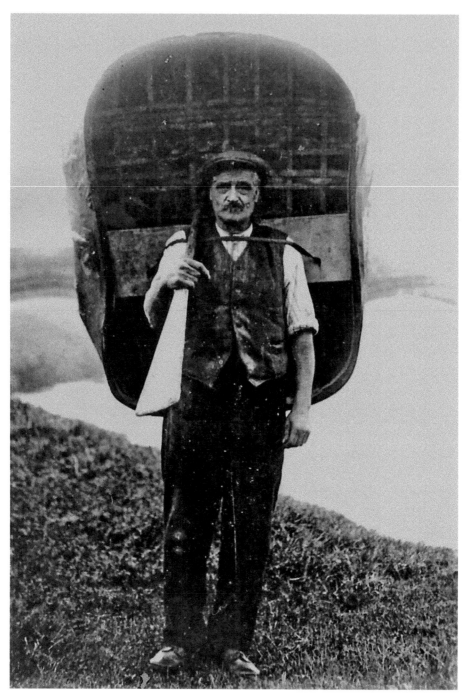

Charlie Johnson, one of the founders of J. Johnson and Son, and a local fisherman, his coracle held on his back by the carrying thong. He was spokesman for local fishermen at the Dee Conservation Board and the Fisheries Commission in London. He also saved many people from drowning and received a Royal Humane Society award as a result. (National Coracle Centre)

WILLOW BASKET MAKING

James Johnson and his brother Charlie earned a living coracle fishing, catching salmon in the river at Bangor-on-Dee. When the catch was poor they would cut willows growing alongside the river and take them home to make baskets, which they would sell. Due to reduced salmon numbers, it became increasingly difficult to obtain permits, so the two brothers had to rely more on basket making for a source of income. One of James' sons (also named James) was seriously wounded in the First World War. Part of his rehabilitation was basket making. He became interested in the craft and on leaving hospital served a two-year apprenticeship with a firm of basket makers in Leeds. He moved back to Bangor-on-Dee to work with his father, and they planted their own willow bed around a mile from the village. The demand for baskets outstripped the rate the family could produce them, so they also sold products made elsewhere and diversified into cane furniture. The traditional methods of basket making have been passed down the Johnson family from generation to generation for 140 years.

J. Johnson and Son continued through five generations, extending to cane furniture and closed on 6 February 2019.

PEAT CUTTING

The county borough boundary cuts across the lowland raised bogs in the south-east. Peat was cut from them for 500 years until 1990. The output of the later factory included 'dust' and 'throughs' (both forms of fine, granulated dry peat used in packing and cattle feed) and 'litter' and 'tailings' (forms of coarse/medium, granulated dry peat used for livestock bedding and deep-litter poultry systems). The product was also sold for horticultural use and 'turf blocks' were sold for fuel. Until the 1940s some houses round the bogs were insulated with peat. The bog provided small-scale employment in these activities for many years, but in the late nineteenth century production became more commercial. In the 1880s a narrow-gauge tramway to the factory increased production, and a further increase took place in the 1920s. Mechanised cutting began in 1968 and quadrupled in 1989, but ended in 1990. Drainage of some of the bogs took place with the Enclosure Acts, and the building of the canal (1804) and the railway (1863). Land at the edges would be 'sweetened' by lime transported on the canal. The bogs are now a National Nature Reserve.

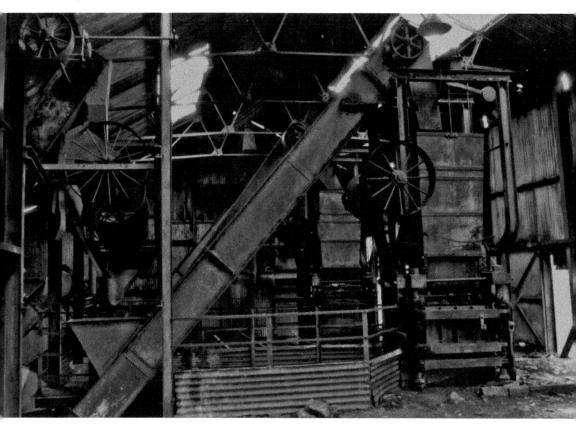

Fenn's Moss factory was built by the Midland Moss Litter Company in 1938 to replace an earlier works destroyed by fire. It processed 3,000 tons of peat in 1954 and operated until the early 1970s. At the works, hand-cut peat blocks were crushed by three hammer mills, sieved, then passed via elevators and trammels through rotary screens to be pressed into bales. The machinery was belt driven from a heavy-oil engine. A tramway transported peat to the works. (Mike Penney)

CANALS

There was a proposed canal route that would have created a link between the River Severn at Shrewsbury and the Port of Liverpool on the River Mersey. A less-expensive possible course was surveyed further to the east. However, the westerly high-ground route was preferred, being more direct and taking the canal through the mineral-rich coalfields of north-east Wales. Only a short section of the western route was completed because the capital required was not raised. Most major work on the line ceased after the completion of the Pontcysyllte Aqueduct in 1805. The Ellesmere and Chester canal companies merged, thereby completed a circuitous route to the Mersey (60 miles compared to the later 12 by rail).

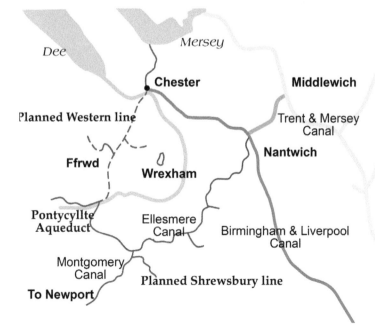

The canal network around Wrexham.

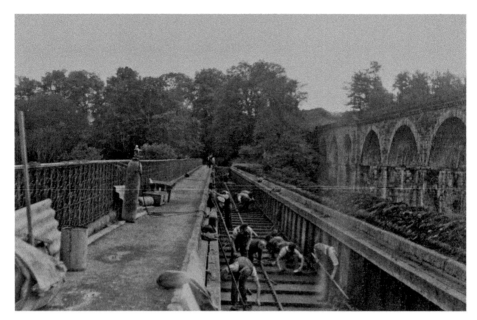

Telford's inspired design for Chirk aqueduct laid a cast-iron trough in the stone aqueduct. The trough can be seen here to good effect while under repair in the 1930s. Originally, the iron plates were just at the base, the sides being added in 1870. The stone aqueduct is 710 feet long and 70 feet high with ten arches, and was completed in 1801. Note the towpath on the left and the Shrewsbury line railway viaduct on the right. (Canal & River Trust Archives)

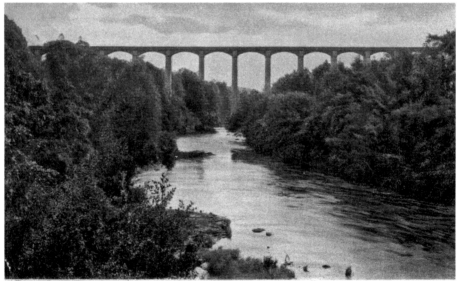

Pont Cysytllan Aqueduct.

The breathtaking Pontcysyllte Aqueduct is an eighteen-arched stone and cast-iron structure, the plate for the trough being made in nearby Plas Kynaston foundry. Completed in 1805, it is now a World Heritage Site. (Canal & River Trust Archives)

The only section of the western canal route to be built was a 3-mile section from Gwersyllt to the Ffrwd. There is some debate as to whether it ever even carried local traffic.

RAILWAYS

The failure of the canal's western line left the rich industrial areas to the west of Wrexham with relatively poor transport links to the Dee. Until then the area had seen a number of horse-drawn industrial tramroads, which were simple but effective; for example, the Ruabon Brook and the Clywedog tramroads and Isaac Wilkinson's Bersham–Ponciau route. It was the arrival of 'new blood' to the area that got things moving. The 1844 Act for the first railway in the area – the North Wales Mineral Railway – was promoted by Henry Robertson, a young engineer from Scotland (also a partner in locomotive builders Beyer Peacock). He and others had moved to the area to redevelop the ironworks at Brymbo, which had declined badly since John Wilkinson's death. The plan was to create a railway between Chester (including a Dee branch at Saltney) and Ruabon together with mineral branches to the lucrative industrial hinterland. George Stephenson's earlier survey of 1839 was a major influence. It took two years to build and was opened in 1846 as the Shrewsbury & Chester Railway (SCR). Robertson engineered the line himself and the contractor was the internationally renowned Thomas Brassey from the Chester area. The mineral branch to Brymbo and Minera left at Wheatsheaf Junction. A laborious two tunnels and two rope-worked inclines took it the 5 miles to Brymbo.

The line quickly became a pawn in the railway mania of the period. It had promise as part of a route between London and the Mersey, in competition with the voracious London & North Western Railway's route via Crewe. Partly for the purpose of balancing the share of routes between the major companies, in 1854 the SCR became part of the mighty Great Western Railway (GWR).

The original route to Brymbo and Minera continued until 1862 when the GWR opened the new branch to Minera from Croes Newydd with no tunnels or inclines. Despite the improved

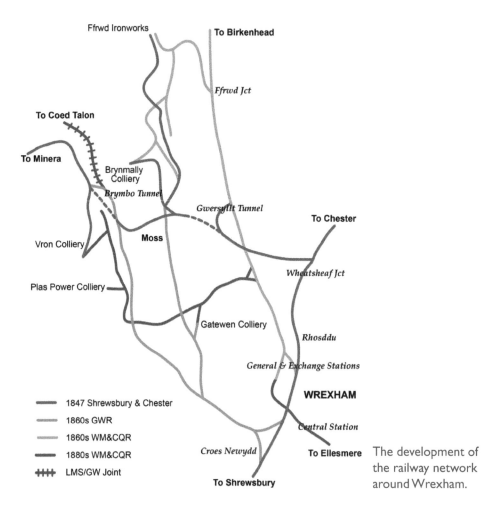

Ffrwd Ironworks

To Birkenhead

Ffrwd Jct

To Coed Talon

To Minera

Brynmally Colliery

Brymbo Tunnel

Gwersyllt Tunnel

To Chester

Vron Colliery

Moss

Plas Power Colliery

Wheatsheaf Jct

Gatewen Colliery

Rhosddu

General & Exchange Stations

WREXHAM

——	1847 Shrewsbury & Chester
——	1860s GWR
——	1860s WM&CQR
——	1880s WM&CQR
++++	LMS/GW Joint

Central Station

Croes Newydd

To Ellesmere

To Shrewsbury

The development of the railway network around Wrexham.

route, industrialists in the Wrexham area felt the GWR held an unhealthy monopoly. The quay at Saltney was not viewed as ideal, as it was a longer haul up the Dee for ships than Connah's Quay.

A vision was developing of building a line northwards to Connah's Quay, and perhaps crossing the Dee to a port on the developing Mersey. The Wrexham, Mold and Connah's Quay Railway (WM&CQR) was duly promoted and authorised to build a line from Wrexham to a connection with the Buckley Railway, which continued to Connah's Quay. In due course the WM&CQR agreed to take over the working of the Buckley Railway. The main line opened in 1866 as a single track. Its original terminus at Wrexham was adjacent to the GWR station (later to become Wrexham Exchange).

A passenger service commenced between Wrexham and Buckley but the section beyond, down to Connah's Quay, remained freight only until closure. A period of steady expansion and consolidation followed for the WM&CQR. Trains on the WM&CQR ran north to Bidston near Birkenhead. They also built a line to Brymbo with several industrial branches. The line south was extended in 1887 by the WM&CQR turning east under the GWR line to Wrexham Central. In the 1890s, Wrexham & Ellesmere Railway continued this route through Bangor-on-Dee to Ellesmere. The line oddly eventually became the only Welsh outpost of the London & North Eastern Railway.

Wrexham had become a railway centre and the railways a major employer. Not only were there two engine sheds requiring footplate crew and ancillary staff, but also workers to maintain the whole rail infrastructure. Rail was the main means of freight transport for many decades but declined in the course of the twentieth century. The Ellesmere line closed to passengers in 1962. Wrexham General's status was downgraded in 1967, when British Railways withdrew through services between Birkenhead and London Paddington. The north–south route survived the cuts of the 1960s; the carriage of steel produced in Shotton and wood for the Kronospan factory helped booster the argument in support. Later, however, some of the line was reduced to a single track up to Saltney. Services improved in 2005, when Arriva Trains Wales introduced regular hourly trains via Wrexham from Holyhead to Shrewsbury, continuing alternately to Cardiff and Birmingham. The fusion of Exchange and General stations was completed in 2011, when Network Rail provided a passenger lift to ensure everyone could access one half of the station from the other, without a detour over the road bridge.

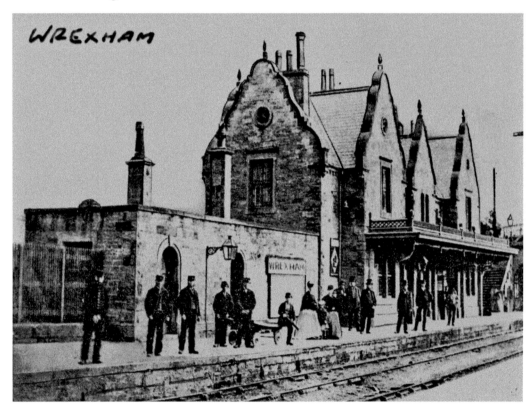

The staff are shown in this image of Wrexham's first station, together with the stationmaster and family. The image dramatically illustrates the importance of the railways as a source of employment. The building was designed by Thomas Penson (1790–1859) in a striking Jacobean style with Dutch gables. Penson's father was a mason who branched into architecture. His youngest son, Thomas, was one of the key architects of Chester's vernacular revival, an illustration of the development and continuity of work skills within families. Penson also designed many buildings and structures in Wrexham (including the County Buildings) and in the area – as far as Welshpool and Newtown. (Wrexham Libraries)

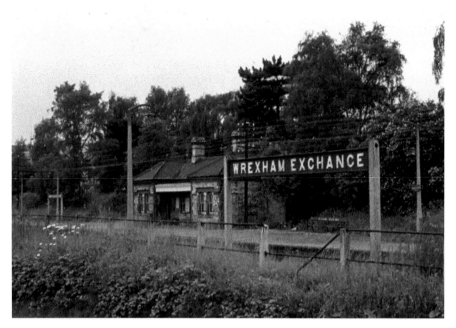

Exchange station, seen here in August 1973, was the original terminus of the WM&CQ Railway and was adjacent to the GWR General station. The WM&CQR was extended to Central station in 1887 so that Exchange became a through station. The fusion of Exchange and General stations was completed in 2011. (Alan Young)

Austin Griffiths has never lost his love of railways since starting in the 1950s as an engine cleaner at Rhosddu shed. Austin was soon firing engines and remembers working on two Shrewsbury-built Sentinel engines small enough to work to the lager brewery siding. He now relives his railway days by running models and reminiscing about his arduous but fulfilling days working steam.

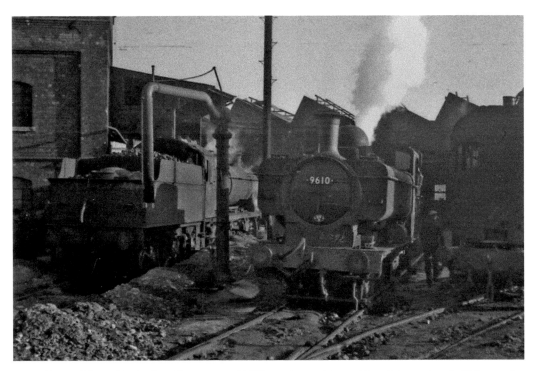

Croes Newydd shed with two ex-GWR engines either side of watering facilities and a steam crane to their right. In the background the shed building is a 'roundhouse' (lines radiating from a turntable) and has a 'northlight' roof designed to provide more constant diffused light. It was built by the GWR and opened in 1902 to replace outdated facilities at Wheatsheaf junction. It was located in the centre of a large fork junction, with the Chester to Shrewsbury line running along one edge and the two lines off the Minera branch on the other edges. The shed finally closed in 1967. Diesel locomotives were stabled nearby until the 1980s. (John Strange)

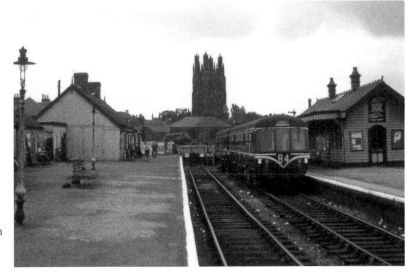

Central station
in the 1960s.
(John Strange)

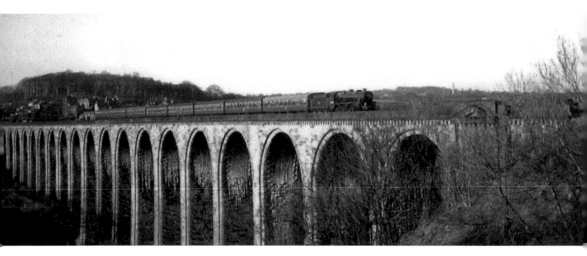

Cefn Viaduct across the River Dee on the Shrewsbury line.

ROADS

There is evidence in a decree by Edward III that a toll road existed between Chester and Wrexham in 1315. The last turnpike road between Chester and Wrexham was constructed in 1756, when the Shrewsbury to Wrexham Turnpike Trust extended its road to Chester. The road carried much traffic. For example, in 1827 and 1828 it was estimated the road was used by 19,000 carriages, plus wagons carrying freight and people on foot and horseback. It was de-turnpiked in 1877 as part of a national change in road management and the Wrexham District Highway Board took over responsibility. It was in a poor condition and required much work to rectify it. A hundred years later the Welsh Development Agency funded the 'catalytic' A483 dual carriageway. At the point the A5 diverges to the west at Chirk, the A483

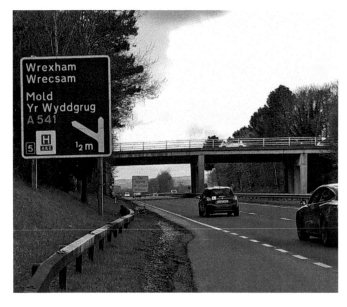

The A483 through Wrexham.

Tollhouse in Rhosnesni on the Wrexham and Barnhill Turnpike.

crosses the River Dee, then reaches Ruabon. Here, it becomes a dual carriageway until the southern outskirts of Chester.

TRAMS AND BUSES

The important coal mining district to the south and the town of Wrexham presented a possible lucrative transport corridor. People from Wrexham commuted south for work and Rhosllanerchrugog (Rhos) inhabitants travelled into town for everyday business. Entrepeneurs seized the opportunity and promoted a single 3-foot-gauge line operated by horse haulage between Johnstown and Wrexham. Following Parliamentary authorisation, carriage of goods and passengers on the line started in October 1876. Horse working was described as slow and an application to use steam trams two years later was turned down by the Board of Trade. Eventually an enterprising local coal merchant leased then bought the line.

Nationally, electric traction was revolutionising street tramways around the turn of the century. The British Electric Traction group acquired the Wrexham horse tramway in 1900. Dick, Kerr & Co. converted the line to 3-foot 6-inch gauge and electrified it for them. The new service started on 4 April 1903 and was extended in the May past the GWR railway station to the Turf Hotel. From Johnstown, the line was extended to Rhos in late 1904. A further extension to Ruabon had been authorised but was never built.

The settlement and therefore the population served was growing in the early twenty-first century, so the tramway flourished. However, as early as 1912 the tramway company had

started experimenting with bus operation, which flexibly tapped new areas of traffic. Bus competition was fierce; the military authorities had disposed of much surplus equipment, including motor buses, allowing rival companies to establish. Additionally, Wrexham Council issued hackney licences freely to anyone requesting them. The GWR ran bus services too. Traffic still continued on the tramway and in 1920 a second depot was opened, on Maesgwyn Road. It closed to trams after a mere five years and was then used as a bus depot. Eventually the tramway closed in March 1927.

Today most bus services are operated by Arriva Buses Wales, although there are other operators based in and around the county borough, running a combination of tendered and commercial bus services. As well as serving Wrexham, services operate to west Cheshire, Denbighshire and Shropshire.

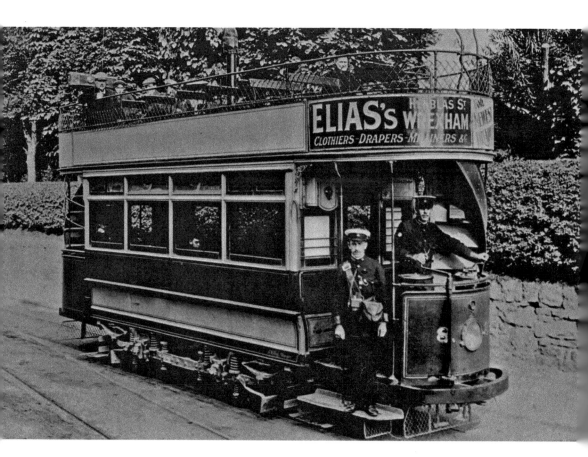

The eager-looking driver, seen here accompanied by his smartly turned-out conductor, must have faced fierce weather conditions at times from his exposed position. Tram No. 8 is seen at Cemetery Loop. It was one of the ten passenger cars delivered by Brush in 1903 and carried twenty-two people downstairs and twenty-six on the upper deck. The cars had no fewer than four braking systems. Due to the steepness of Vicarage Hill, one of these systems was the 'Spencer electric skotch', powerful enough to lift the car off the ground. (Wrexham Libraries)

The depot built at Johnstown for the new electric cars was described by the *Rhos Herald* as a 'magnificent building'. Its construction provided work for local contractors and a market for Ruabon brick. The depot survived long after the closure of the tramway, with one subsequent use being a bus garage for the Crosville Company. It was finally demolished sometime between 2005 and 2010.

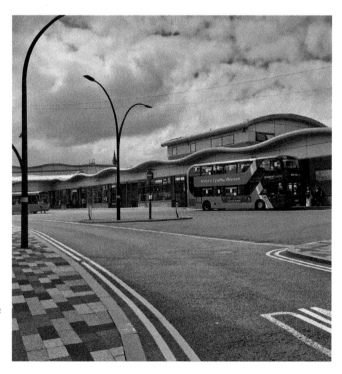

An Arriva Buses Wales Enviro 500 double-decker at Wrexham bus station. It was built by Alexander Dennis Ltd. The station was opened in two halves in December 2003 on the site of the original 1950s building. In 2013, the station benefitted from a £1.4 million improvement project, which saw the installation of wider pavements, shopfronts, walls and other infrastructure. The scheme was backed by the European Regional Development Fund.

WREXHAM, THE TOWN

Workers in such a productive area required many facilities and services. Wrexham became the centre and the services became a major source of employment. In its early days it developed as a centre for administration. Historically part of Denbighshire since the Act of Union in 1536, the borough of Wrexham was incorporated as a town in 1857. The town became part of Clwyd in 1974. Since 1996, it has been the principal centre of Wrexham county borough.

Today, Wrexham continues to serve North Wales and the Welsh borderlands as a centre for public services, commerce and culture. The provision of these functions provides many opportunities for employment. In this chapter we see some of the different ways that Wrexham has become a hub for the area.

The visible face of local government is the neo-Georgian Guildhall. It was built in 1960/1 at a cost of £150,000 and had been in the planning for many years. (Wrexham Libraries)

EDUCATION

Glyndwr University received its charter in 2008 and now has 8,000 students. It previously had been the North East Wales Institute (NEWI), which first started to offer degrees in 1924, originating as the Wrexham School of Science and Art founded in 1887.

Coleg Cambria Yale is part of a higher education institute, with several campuses across north-east Wales. The two in Wrexham that formed the Yale College became part of it in 2013. Together with a number of secondary schools and the seven primary schools, education is a significant employer in the county borough.

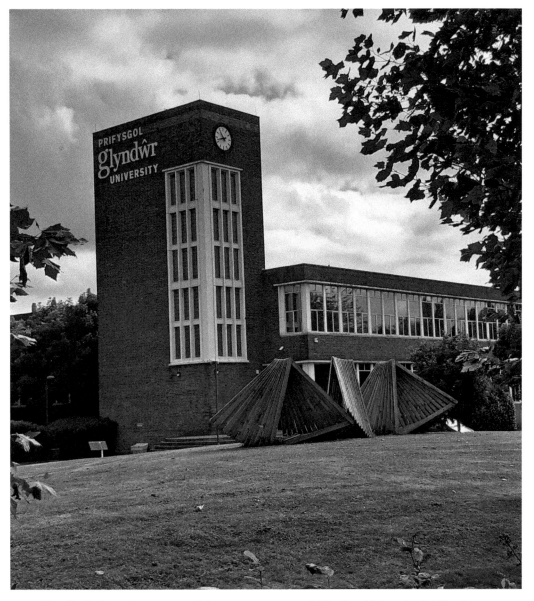

Plas Coch, the main campus of the two campuses of Glyndwr University in Wrexham.

HEALTHCARE

Proper healthcare was inaccessible to poor people in Wrexham until 1833 when the Dispensary on Yorke Street opened. It provided care to those unable to pay for it yet not receiving poor relief. The care provided was not unconditional; wealthy people who provided the finance could recommend people for treatment. Maelor Hospital is now the region's major acute district hospital, with over 980 beds. It had its origins in the Wrexham Union Workhouse (1838) together with a nearby new infirmary, a fever hospital and a home for the elderly and infirm (Plas Maelor, opened in 1934). The latter joined the NHS as Maelor General Hospital in 1948. The hospital was rebuilt using a nucleus layout and reopened as the Wrexham Maelor Hospital in 1986.

The original infirmary with its neoclassical front and portico opened in 1838, replacing the dispensary. A bazaar to raise money for a new infirmary the previous year had raised £1,053. By 1860 it was treating 2,000 people a year. Serving as Wrexham's hospital until 1926, it then became part of the Denbighshire Technical College. Since 1953 it has been a successful art college and is now part of Glyndwr University.

Dr Worrall was obviously much appreciated by the colliers.

The Wrexham & East Denbighshire Memorial Hospital was built to mark the sacrifice of local servicemen killed during the First World War. Many people contributed to the cause; the William and John Jones Trust (set up by the former owners of Island Green Brewery) gave £50,000 to start the appeal. The Walter Roberts Pantomime Company raised enough money each year to staff a ward. The Prince of Wales laid the foundation stone for the hospital in 1923. The hospital opened in 1926, replacing the Infirmary. It had 103 beds compared to the Infirmary's fifty-four. The hospital served the local community for sixty years until 1986. The building is now part of Coleg Cambria.

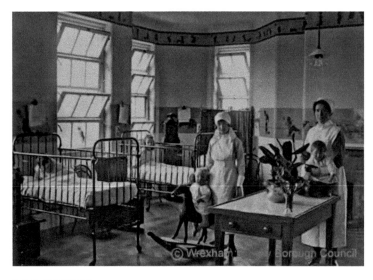

Children's Ward at the Wrexham and East Denbighshire Memorial Hospital. Money raised by the annual Walter Roberts pantomime paid for the Children's Ward and its running.

MILITARY

Hightown Barracks provides a focus for Wrexham's identity as a military town. Established in 1877, it was part of the localisation of military forces. The 23rd Royal Welch Fusiliers established it as their depot and have continued to use it periodically along with other regiments. Historically, military work has taken a number of forms. In the Civil War both sides were at different time billeted in the town. The Denbighshire Militia were an important force in the quelling of industrial unrest in the late nineteenth century. The barracks were a centre for recruitment in the First World War.

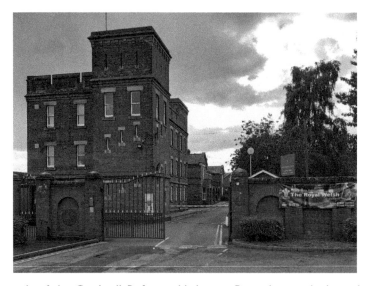

In 1877, as a result of the Cardwell Reforms, Hightown Barracks was built in the Gothic Revival style. The militia left the County Buildings and moved there with the two battalions of the 23rd Royal Welch Fusiliers.

The County Buildings was originally the HQ of the Royal Denbighshire Militia when it opened in 1857. Initially, the building had four towers, and there were even plans for a dry moat and steel shutters due to the social unrest then in the county. The buildings additionally provided accommodation for senior officers and their families. The local Rifle Volunteers and the Denbighshire Yeomanry Cavalry also used this building. In 1877, the militia moved to the new barracks, allowing the police and magistrates to move in two years later. Previously they had been accommodated in the old Town Hall. Upstairs, the former armoury became a courtroom and cells were built. The building now houses the museum.

COMMERCIAL SERVICES

Stability under the princes of Powys Fadog and its position enabled Wrexham to develop as a trading town in the eleventh century. Historical documents from 1327 onwards refer to the town as a *villa mercatoria* (market town). The economic character remained predominantly as an agricultural market town into the seventeenth century. Retail demands led to the development of several shopping streets (e.g. Hope Street) and arcades. In recent times major retailers such as New Look and WH Smith have become established and new retail parks built. Plas Coch and Berse retail parks are on the outskirts close to the A483. Central, Island Green and Eagles Meadow retail parks are in the town centre. The town now has the largest retail sector in North Wales, which is a significant source of employment and a vital sector of the local labour market.

Like many similar market towns, Wrexham had a core business support and banking service. The Industrial Revolution pushed the development of this sector to support the massive increase in local industry. Today, in the modern industrial world, financial services in the county borough represent a major employment sector. Wrexham is now home to a number of finance companies with often niche portfolios. The Depository Trust and Clearing Corporation for example collates and analyses company information for investment banks and financial organisations. Moneypenny is UK's largest outsourced switchboard and personal assistant service. Chetwood Financial (licenced 2018) is a 'fintech' company whose purpose is to develop computer programmes for the banking and financial services.

Wynnstay Arms Hotel on Yorke Street was built in the mid-eighteenth century. It has been heavily altered since then, but the original frontage survives. The ornate, cast-iron balcony has significance as both Gladstone and Lloyd George delivered speeches from here. The latter announced here in 1918 that the First World War had ended. The Football Association of Wales was formed at a meeting in this hotel in February 1876.

Around the side of the Feathers Hotel, another of Wrexham's coaching inns, is the old stable yard. The round aperture, now a window, would have been the opening for hay for the loft. The inn was on a popular drover's route along Wrexham's main thoroughfare to the beast market.

Central Arcade with eighteen shops, a studio and offices ran from Hope Street to the Butchers Market. Its construction was first mooted in 1890. A public company was set up to build it and opened it the following year. It has a fine terracotta frontage and a clerestory glazed roof.

The Butchers Market was designed by Thomas Penson and built in 1848. It included a corn exchange room on the first floor and an inn. Butchers and other traders had always sold their products in the street, but there was a trend to moving them indoors during this period.

The General Market was opened in 1879 to give indoor accommodation to some of the many traders in butter, cheese and other dairy goods with the aim of improving food hygiene. Thus, it was known as the Butter Market, but was later renamed. During the Second World War it was used as a dining hall for officers of the US Army Medical Corps, who were billeted nearby.

New shopping areas have been created within the town at Henblas Square, Island Green and Eagles Meadow. Eagles Meadow is a shopping centre with more than sixty shops and a leisure development with a bowling alley and a cinema. It is connected to Yorke Street and High Street by a bridge.

Chain stores in the past had style, as shown by the mosaic and the monogrammed post at the entrance to this Chester Street shop. Maypole was an early dairy chain with 105 shops nationwide in 1905.

The Midland Bank building was built between 1910 and 1912 to a design by Woolfall and Eccles. The site for this building was originally bought in 1905 for the North & South Wales Bank (NSWB). However, before they could build the NSWB became part of the Midland. Wetherspoons have cleverly rekindled the old name for the building in its new guise as a pub. The NSWB had been set up in Liverpool in 1836 and a Wrexham branch opened the same year in Mr Griffith's house and shop in the Market Place. The bank later had premises in part of the Alliance building opposite to this one.

The old Midland Bank building still has some original features. In the ceiling is this glazed panel, leaded with iron support bars and with a coloured margin design of ribbon and garland.

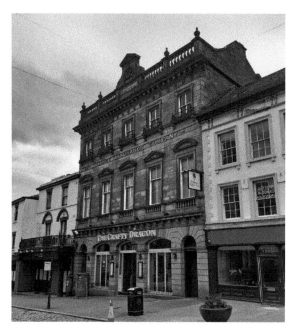

The Provincial Welsh Insurance Company moved to this building in 1861 having been founded in Wrexham in 1852. The insurance offices were on the upper floors of the building, with the ground floor occupied by the North & South Wales Bank. The Alliance Assurance Company (founded in London in 1824 by Rothschild and Montefiore to rival and circumvent Lloyds) took over the Provincial Welsh in 1899. In 1959, the Sun Insurance Office merged with the Alliance to form Sun Alliance Insurance Limited. Designed by Richard Kyrke Penson (1815–85; oldest son of Thomas) in the baroque palazzo style in 1861, it is now a public house.

SPORT

Wrexham has a strong sporting heritage spurred on by the often passionate support of local people. The Football Association (FA) of Wales was formed in Wrexham in February 1876 in opposition to a view from the south that Wales should be represented by a rugby team. Wrexham remained the headquarters until relocation to Cardiff in 1991. In October 1864, Wrexham Football Club – the oldest Welsh club in the football league – was formed, and play at the Racecourse Ground. The football training ground, Colliers Park has received a substantial investment to improve the facility, which was financed by the FA of Wales and is now recognised as a National Development Centre.

Queensway International Athletics stadium in Caia Park is Wrexham's second stadium after the Racecourse, and has hosted the Welsh Open Athletics event in recent years. The stadium is also home to North Wales' largest athletics club, Wrexham Amateur Athletics Club. From 2017, it is home to rugby league side North Wales Crusaders.

The range of modern sporting opportunities in the county borough is very varied. Wrexham hosts the regional Hockey Stadium and the regional tennis centre both with attached clubs. The county borough has four golf clubs and seven leisure centres offering activities, including swimming, aerobics, climbing walls and yoga.

The relationship between sport and work is interesting. At the stage where industry was reorganising into larger units, companies were often making an effort to improve workers' welfare. It is interesting to note many of the local sports clubs (for example, the hockey and football clubs) started in the late nineteenth century, sometimes receiving industrial sponsorship. The local breweries were associated with local sporting events. The Racecourse football ground round was owned by Soames' Brewery and had a 'Border Stand' for many years. In the early twentieth century it is recorded that, for example, there were walking races between employees of different brickyards. Over the past century much employment has required less physical effort. Perhaps as a result there is more interest in active participation in sport rather than spectating. The organisation and management of sport obviously in itself provides much local employment.

The Turf Hotel, where the football club, the oldest Welsh club in the Football League, was formed. Behind is the Racecourse Ground, the home of the club, which has also been used for some of Wales' home internationals since the first one in 1877. The ground has also seen rugby union, cricket and concerts performed before large crowds. The ground was originally developed for horseracing by Sir Watkin Williams Wynn of Wynnstay in 1807 and continued through to 1858. It is now owned by Glyndwr University.

Wrexham AFC was founded in 1864 by members of Denbighshire Cricket Club, who played on the Racecourse.

Queensway Stadium in Caia Park is used for athletics and rugby league.

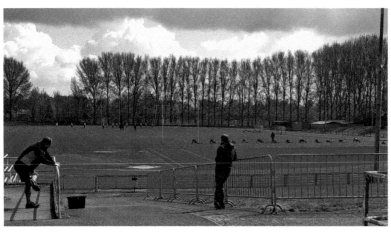

The Crusaders Rugby League team at their Sunday morning practice.

CULTURE

In 1876, the 'Art Treasures & Industrial Exhibition of North Wales' was accessed through the still extant Argyll Arch. The juxtaposition of art and industry is interesting and was more clearly connected at that time. It is said the Wrexham School of Science and Art developed as a result of the exhibition. Later it became Denbighshire Technical College. Today the School of Art and Design is a vibrant section of the university.

Clearly cultural activities provide work and also leisure activities for enjoyment and developing creativity when not in the workplace. There is a very long history of cultural work in the county borough – a company of actors from Wrexham is recorded as appearing in Shrewsbury in Henry VIII's reign. Wrexham has often hosted the National Eisteddfod. Wrexham has a number of theatres and a multiscreen cinema. Tŷ Pawb ('Everybody's House') is Wrexham's largest facility for visual arts and exhibitions.

The Argyll Arch formed the entrance to the Art Treasures & Industrial Exhibition of North Wales & the Border Counties, held in 1876.

Medal struck for the Art Treasures & Industrial Exhibition of North Wales.

The Elihu Yale was built originally in 1910 as a skating rink. It was soon screening moving pictures. Remodelled with a new façade and art deco interior in 1930, it continued as a cinema, known as the Majestic until 1960. Prior to opening as a pub in 1998, it was a Fine Fare supermarket and a furniture warehouse.

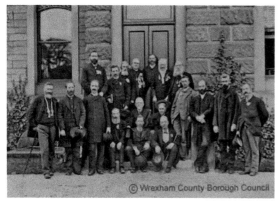

The Gorsedd (modern-day bards) meet at Wrexham during the 1888 National Eisteddfod.

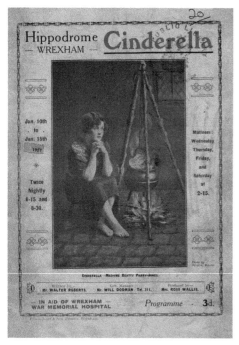

The Wrexham Hippodrome was built in 1909 and constructed on the site of the former Public Hall and Corn Exchange, which had been inaugurated on Tuesday 3 June 1873, but was destroyed by a fire in 1906. The Hippodrome showed live plays and variety shows until 1929 when it was converted to a cinema. It finally closed in 1998 and was demolished in 2009. (Wrexham Libraries)

REGENERATION

Wrexham has reinvented itself twice. In medieval times it was an agricultural and trading centre. Wrexham was one of the cradles of the Industrial Revolution, which not only transformed manufacturing processes but also led to great social change.

However, this was not the end of the story. Only 100 years later, in the 1930s, the heavy industrial presence began to wane. Over the next fifty years this decline continued exponentially. Many coal mines closed first, followed by the brickworks and other industries, and finally the steelworks (with its own rail infrastructure). The last pit to close in the county borough was Bersham Colliery in 1986. The leatherworks in Pentrefelin and Tuttle Street, the brickworks in Abenbury, Brymbo Steelworks and the breweries all closed in the latter half of the twentieth century. Wrexham suffered from the same problems as much of industrialised Britain and saw little investment in the 1970s. Like many areas in that period of 'de-industrialisation', Wrexham faced a crisis. On the surface this presented as economic. People wishing to migrate from the area struggled as house buyers were uninterested in an area where there was little employment. Perhaps felt more deeply was a crisis facing the identity of the local community. The future of the district was uncertain.

Some regeneration overlapped with the 'death' of traditional industry in the area. In 1945, the Royal Ordnance Factory to the east of the centre closed. The site was used in the 1950s for a British Celanese factory, producing acetate yarn. A Firestone tyre plant was constructed following this. In the 1980s and 1990s, the Welsh Development Agency (WDA, 1976–2000) funded the A483, a major dual carriageway aligned just to the west of the town centre. Over the years England's trunk road network had not included a Wrexham link, so the new road made this connection and to the port of Holyhead.

The WDA helped the old ROF site further develop, and it was designated an industrial estate. British Celanese and Firestone were joined by Kelloggs, JCB, Village Bakery, Calypso Drinks and Tritech and many others on the site. The Wrexham Industrial Estate became one of the biggest in Europe, home to around 300 businesses employing in the region of 7,000 people. This was not the only development. No less than fourteen other industrial estates were opened throughout the county borough. In many cases these are located on or close by the site of earlier heavy industrial sites, around which communities had developed that now had employment needs. Wrexham started taking on a new identity and is now the main

commercial centre in North Wales, and has been able to gain exposure to growth sectors such as new technologies. The county borough has become a hub for high tech manufacturing, bio-technology, financial and professional services.

In 2007, Wrexham was ranked fifth in the UK for business start-up success. It moved up to second place in 2020. On average eight new businesses were established per 10,000 adults each year, against the UK average of six. The Wrexham Gateway Partnership is continuing to develop its plans for the regeneration of the area to the west of the town along the Mold Road. Parallel to this is the Technology Park development on the same side of town. A study by Sheffield University of regeneration in UK regions that previously had coalfields found considerable variability. North-east Wales and Durham have recovered very well. This is in sharp contrast to the areas of Lancashire and Northumberland that earlier had coal fields. Once again the people of Wrexham have shown great resourcefulness backed by local and national government agencies in promoting a new identity for the county borough.

A derelict building from the Royal Ordnance Factory built near Marchwiel in 1939 and operating throughout the Second World War. It was one of four factories in the UK producing solventless cordite, which was an explosive propellant used in shells and rockets. Covering 5,666 hectares and employing 13,000 people at its peak, it was served by an extensive internal railway system branching from the former Cambrian Railways line between Ellesmere and Wrexham. Closing in 1945, the site became the Wrexham Industrial Estate.

Kendal works in the JCB Wrexham factory for the Controls and Calibrations department. She says, 'My dad brought home the advertisement for the JCB Controls and Calibrations Apprenticeship and it was exactly what I wanted. It meant I could earn money while still completing education, and gaining qualifications and on-the-job knowledge. I completed in September 2020 after four years and this is a great achievement for me as I now have my full-time contract.' (JCB)

Alan Gough, pictured at work at JCB Transmissions on the DualTech VT transmission assembly line. A recently retired employee of forty-two years said, 'When I came to JCB it was like an engineering paradise and it has been ever since.' The two factories at Wrexham make axles and gear boxes. The first factory opened in 1978 and the second one, opened by the Duke of Edinburgh, in 1998. The Wrexham factories currently employ more than 300 people. (JCB)

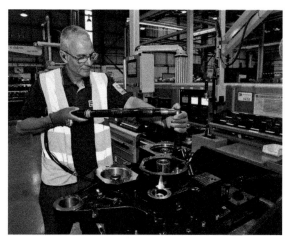

The estate is the location of the UK's largest prison, HM Prison Berwyn, which opened in 2017 on the Firestone factory site. It is intended to eventually house over 2,000 adult male prisoners. The prison is designated Category C – one category more secure than an open prison.

Redwither Tower was once a major factory for yarn manufacture, spinning and knitting. The factory was built in the mid-1950s, and 2,000 people worked on the site when it was at peak production. Wrexham Council reopened the building and the surrounding area as a business Park in 1990. It is on the Wrexham Industrial Estate.

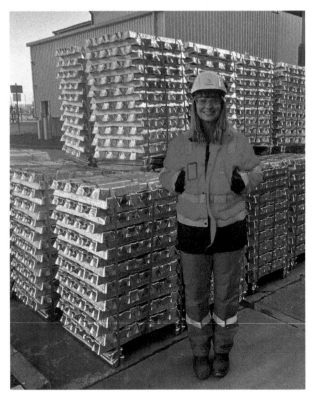

Lucy Thomas, a highly motivated graduate, has been Materials Manager at Norsk Hydro ASA on Wrexham Industrial Estate since June 2017. She is responsible for managing daily operations in the plant and for purchasing 35,000 tonnes of scrap aluminium annually. Norsk Hydro ASA is an aluminium and renewable energy company. Another multinational company, it is Norwegian owned. In Wrexham, Hydro has an aluminium remelting facility producing 60,000 tonnes of extrusion ingot per annum. (Norsk Hydro ASA)